Auerbach's

Auerbach's

The Store that Performs What It Promises

EILEEN HALLET STONE

THE
History
PRESS

Published by The History Press
Charleston, SC
www.historypress.com

Front cover: A modernization sale at Auerbach's, 1934. *Utah State Historical Society.*
Back cover: Early 1930s sale at Auerbach's. *Utah State Historical Society.*

First published 2018

Manufactured in the United States

ISBN 9781467137454

Library of Congress Control Number: 2018942441

To Daniel and Randy

CONTENTS

CONTENTS

CONTENTS

LOOKING FORWARD:
"SUBTLY DIFFERENT; TALLER, MAYBE"

I'm a shopper. I've always been a shopper. Some people get their thrills parachuting down to the ground, some climbing up to the clouds. Not me. I go in. I go in to shop.

There's something special that happens in a department store like Auerbach's. First of all, it's the people, lots of people, building on or reinventing their personae. Spray by spray, shoe by shoe, a new shirt here, a pair of trousers there. And they seem so happy with their new selves. The salespeople, all experts in their particular field, know exactly what is needed for a successful makeover. Their help is invaluable as they put together perfectly orchestrated symphonies of ensembles.

I go in feeling OK but somewhat shabby. My clothes are not worn out but tired. They've worked hard and are no longer interested in their job. I think they would prefer to be hung up and left alone for a while. Maybe it's me; maybe they have given me all they can and would prefer working for somebody else, somebody more exciting perhaps.

The dapper gentleman in the sport coat department looks my way and smiles. Electricity buzzes around me. I've found the specialist for my individual malady. I inhale the rich aroma of fine imported wools as I approach the salesman. He has a look of confidence, an air of knowing as he nods ever so slightly. We shake hands, and I realize these are the hands that will be responsible for my transformation. With a neurosurgeon's precision, he will lift me from my funk and put a stride back in my step.

As the metamorphosis approaches its completion, I look in the mirror and see myself, not unlike the other happy shoppers. Yes, it's me, but subtly different. I think taller, maybe. I'm ready to go for that promotion, ask out that pretty blonde, walk as if I know where I'm going. I'm on my way.

I really must do this more often.

Michael Hallet,
former retailer/owner, Domus, SLC
Domus Isle, Bar Harbor, Maine[1]

ACKNOWLEDGEMENTS

Sometimes out of the blue, I am just dropped into the history of others. Such was the case years ago when Salt Lake City collector Stan Sanders said, "Just a minute," delved into his archives and plunked staggering reams of Auerbach family papers into my arms, along with a couple of fine photographs to whet my appetite. "This is a good story," he said. "Do something, before everyone forgets."

Several years later, Frieda Lee Auerbach called me to her home at the mouth of Emigration Canyon and dumped—she was clearing house—identical volumes into my arms. I don't remember what we talked about, but we had a good cup of coffee.

And last year when Artie Crisp, commissioning editor for The History Press, called with a request for a book on an early department store, I got the picture.

I felt fortunate to once again be given free rein, this time to delve into the Auerbach's store (1864–1979) and the incredible story behind it. I am most grateful for the copies given me, as they contained Samuel and Eveline Auerbach's memoirs, whose writings I have excerpted (slightly edited) and quoted for this book. I would like to thank Peter E. Hanff, deputy director of the Bancroft Library (University of California, Berkeley, where the original Auerbach memoirs are held) for his kind assistance with my research. The university has published Samuel's memoir in its entirety.

I am "over the moon" with gratitude that those related to the family and those who shopped and worked there remembered much and

enthusiastically shared their experiences. At times, I was right with them on the fashionable second floor.

I thank the University of Utah J. Willard Marriott Library's Gregory C. Thompson, associate dean of special collections, who consistently encourages me to take on these wonderful Utah stories. I am truly indebted to photograph archivist Lorraine Crouse not only for her rich knowledge of the Auerbach collection but also her willingness to help me explore the breadth of such material; and for Julia Huddleston's fine and timely digital reproductions. I also thank Pioneer Memorial Museum's curator, Kari M. Main, for photographing the Indian tanned leather dress gloves.

I thank Rena Koopman and Brooksie Koopman for their insights and family photographs and Kristina Oschmann, of the Connecticut Historical Society, for digital copies of George Auerbach's letters to Beatrice.

I appreciate former contractor, developer and U.S. ambassador John Price for sharing his perspective on city planning in the 1970s.

I thank Utah State History director P. Brad Westwood for kindly permitting me to use their archives. I am also indebted to Doug Misner and Greg Walz, who helped track down and digitally capture historical images in the best light.

I thank project editor Hilary Parrish and senior designer Anna Burrous for their instrumental help in creating a book of which Samuel Auerbach would be proud.

Finally, I thank my son Daniel Gittins Stone for his kind thoughtfulness and my husband, Randy Silverman, for his wholehearted enthusiasm, wealth of information and contributions to this book.

I apologize for whatever mistakes or omissions may have occurred.

INTRODUCTION

The history of Utah's legendary F. Auerbach & Bros. department store is an epic filled with Wild West stories of gold fields, mining camps, railway men, pioneers and ranchers paralleling the determination, East Coast aesthetics and business acumen of three young Prussian teenagers—Frederick, Theodore and Samuel Auerbach—who, challenged by "an ideological-economic war unique to Utah," succeeded in building one of the first and finest department stores in the West. Appealing to all incomes, tastes and sensibilities, they created a flagship institution that was "open for business" for more than one hundred years and, no longer existing today, enthusiastically lives on in the memories of many.

ONE WONDERS HOW THE JEWISH IMMIGRANT BROTHERS DID IT

How did the Auerbach brothers come to America? What motivated them to go westward and set up mercantile tents in California's Rabbit Creek; trade in gold dust when "paper money was not worth face value"; transport merchandise by mule train to "isolated camps" in the High Sierras; sell wholesale merchandise to teamsters and merchants in Nevada, Montana, Wyoming and Utah; establish branch stores in places like the rich and raucous mining camp of Bodie; and still manage to dress Rabbit Creek's "ladies of aristocracy" in finery?

AND WHY UTAH

With Utah territorial governor Brigham Young's help in 1864, the brothers opened F. Auerbach and Bros. (also known as the People's Store) on "West Side East Temple Street" in downtown Salt Lake City, eventually moving to larger premises on Main Street and then Third South and State Streets. Their first advertising campaign consisted of two-inch copy printed in every issue of the *Daily Telegraph* and strategically increased as the store captured community attention, respect and sales.

The Auerbachs expanded their business in Promontory Summit, Utah, where the golden spike was driven connecting the transcontinental railroad line; in the junction city of Ogden; and in the gateway town of Corinne during the short-lived but disastrous trade wars of 1866 that forced many non-Mormon merchants out of business and out of the territory.

Business savvy, trustworthy and remarkably worldly, the Auerbach brothers related with businessmen, community leaders and everyday people. They developed the Salt Lake City store under family control and

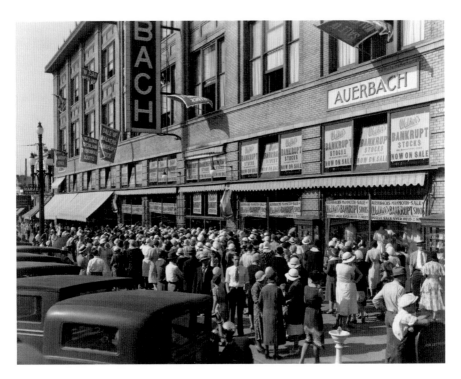

Early 1930s sale at Auerbach's. *Utah State Historical Society.*

management until they believed it "attested to [their] mercantile policies, ideals of service to this community, [their] ability to progress with the changing conditions" and consistently provided something for everyone under one roof.

For more than one hundred years, Auerbach's was a landmark in downtown Salt Lake City. It bridged the no longer but once longtime Mormon/non-Mormon political and cultural divide (it's often been said the north end of Main Street was occupied by those with ties to the LDS Church and the south end was for non-Mormons, or so-called Gentiles).

Auerbach's impressed customers with its expert staff composed of both men and women, stunning window displays, appealing interior design and full array of fine merchandise. And even after closing in the late 1970s, Auerbach's never lost its peerless reputation. Who are the people who worked there? Who shopped there? And forty years after its closing, who remembers the esteemed establishment, Auerbach's, as if it were yesterday?

Part I

WHEREVER BUSINESS COULD BE HAD

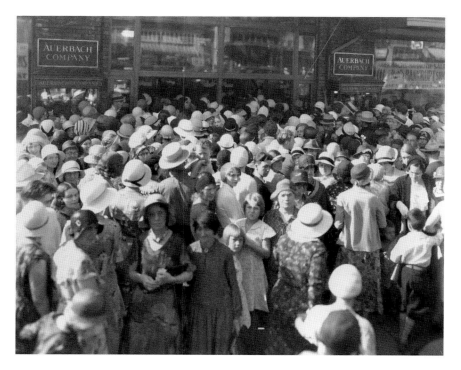

Crowded sidewalk shoppers waiting for Auerbach's doors to open. *Special Collections, Marriott Library, University of Utah.*

Chapter 1

DRIVEN TO OPPORTUNITY

REASONS FOR LEAVING

Spurred by homelands rife with unemployment, indebtedness, rising taxes, crop failures, famines, numerous restrictions and overpopulation, from the early 1800s to 1915, some thirty million Europeans, grasping America as a land of opportunity, immigrated to the United States.[2]

Most were men and young boys between the ages of fifteen and thirty. Many yearned for economic equity and relief from religious persecution. Some wanted to earn enough money to send home to their families and eventually return to them. Others were hungry for adventure and the independence to make a home of their own. More were both pushed from Europe by the political reaction following the revolutions of 1848 and pulled by the news of the discovery of gold in the West.[3] And nearly all were poor.

Aided by relatives at home and abroad, these men traveled great distances just to reach the closest seaport city, where many used their scant funds to lodge in small boarding rooms, sometimes waiting weeks on end before securing cheap passage on rarely scheduled passenger ships. Most carried few personal belongings, food baskets, pillows, blankets and change of clothes with money, letters of introduction and other important papers pinned inside their coats or shirts. Cloistered aboard claustrophobic steerage between decks, they endured long voyages subjected "to the vagaries of wind and weather," incessant ship rocking, rancid food, rough-hewn wooden bunks, stagnant drinking water and lack of privacy.

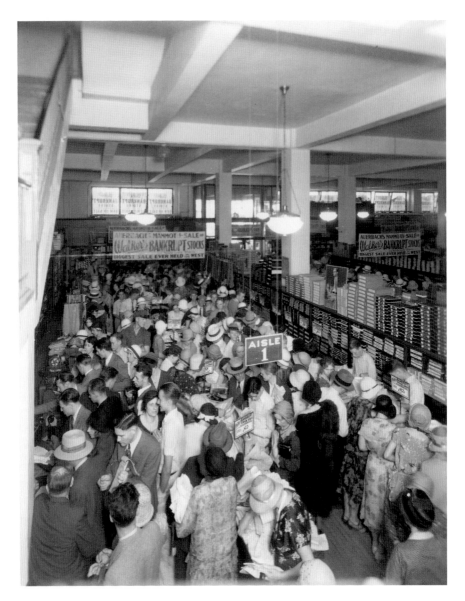

Who could resist the sales galore at Auerbach's? *Special Collections, Marriott Library, University of Utah.*

But like the three Auerbach brothers—Frederick, Theodore and Samuel—who followed one another from Prussia to America, none lacked courage or derring-do.

WHEREVER BUSINESS WAS HAD

Driven to improve their lot, the brothers chose the path set forth by many other young hopefuls of the times. They went wherever business could be had. Taking Frederick's lead, they eventually headed west during the gold rush days and experienced the quixotic nature of California's widespread mining booms and busts. They chased chance in and out of settlements and traveled territory to territory from one gold district to the next. They opened tent stores and wooden shacks in rough mining camps, alongside narrow-gauge railroad lines and in one-street towns. They sold goods and services to a staggering number of peripatetic miners. And defining the true entrepreneur, if one venture failed, they would start another. If it succeeded, they would expand and build up their holdings. In 1864, they turned their attention to Salt Lake City, Utah.

Breaking ground is not without challenges that extend beyond language, geography, religion and culture, but this was the West after all, and the Auerbachs took it on with unyielding courage and true grit.

BEFORE THERE WAS
F. AUERBACH & BROS., THERE WAS
FORDON, PRUSSIA

THE YOUNG BOY AND THE RAGING VISTULA

In the small Prussian (now Polish) town of Fordon, four-year-old Samuel, born on June 15, 1847, loved to walk with his father, Hillel Tobias Auerbach, to the River Vistula and its busy ferryboat service. There, he'd watch his father depart on business trips to the neighboring countryside, and there he'd often be found waiting for his father's return.

In the 1800s, Fordon had a thriving Catholic and Jewish population. Hillel was a noted Jewish scholar of the Talmud, the rabbinic commentary from which Jewish law is derived. He taught at a local college and was fluent in five languages. Hillel was also a businessman, a merchant, who traded in cattle, leather, furs, grain and flour. He was most profitable when it came to buying and selling horses to the Prussian and French governments for their cavalry.

"He was a large and powerful man," Samuel wrote in his memoirs. "On one occasion driving a heavily laden wagon of grain over a sandy stretch of road, the wheels sank so deeply into the fine silt the horses could not move them. Father secured some planks, lifted the wagon wheels onto the boards one time then another for some two hundred yards until the horses and wheels were on solid ground."

Hillel; his wife, Biele (Bertha) Friedman; and their seven children, Rosa, Johanna, Augusta, Rebecca, Frederick, Theodore and Samuel, lived in a small flat in a tall building formerly called the Direction. A customs

warehouse converted into a tenement building, the Direction was once a busy shipping and customs company that administered the flow of imported goods from passing sailing vessels, collected tariffs and brought revenue and commercial repute to Fordon. To Samuel's delight, the Direction's proximity to the river was "just one short street down the hill."

The freshwater River Vistula flows for more than 650 miles. One of Poland's largest waterways, it travels in a south-to-north direction from the western part of the Carpathian Mountains, down steep foothills, through Poland's lowlands, across extensive plains and by the country's most prominent industrial cities, including Kraków, Warsaw and Fordon (a district in Bydgoscvc), until it reaches the port of Gdańsk. From there, the river floods into the delta estuary, branches off into three streams and, in a blended mixture of fresh water and salt, surges into the brackish Baltic Sea.

The Vistula captivated Samuel, who grew up exploring the riverbanks, trails, landings and shallows around him. He recognized all mannerisms of river men, sailors, tourists, travelers, tradesmen and townspeople who passed by the Direction's front stoop, where he often sat. He could also identify the many and varied types of workboats, sailboats, rowing boats and dinghies.

Samuel noted there were fleets of flat-bottom, low-raking (sloping) barges carrying "lumber and hardwoods—oak and walnut—raw furs, flax, goose feathers, turf and wool"; extended rafts made of large logs "or heavy timbers laid crossway and fixed firmly with large wooden pegs to keep them together"; and other craft bound together with "heavy chains on top of the rafts built to stand high out of the water."

Caravans of lightweight river boats—tethered topside with individual canoes hollowed out of one log—often supported on-deck straw-thatched or canvas-covered shanties that sheltered businessmen, families, crew and cargo during rain or rough weather travel.

"Seeing all of them as I did held a great fascination for me and I wished that I too might go on a sailing voyage to faraway lands," Samuel wrote.

An Unexpected Mourning

In mid-July 1851, Samuel's father was driving home from the country with a heavy wagonload of goods when he suddenly lost control of his team. Whether Hillel overcompensated for the wagon's shift in weight or was jolted by a deeply rutted road, the wagon shuddered, the horses reared and Hillel fell over the side and suffered serious injuries.

Before Hillel's accident, Samuel unexplainably lost his sight and was bedridden in a darkened room for weeks on end. Suddenly, on July 19, the child was startled awake and, just as baffling, yelled out that he could see. That same night, his beloved father Hillel died.

A family devastated and deep in sorrow, the Auerbachs struggled with the loss and subsequent financial toll. Samuel plaintively called Bertha "my poor mother." Samuel set out to search along the woody riverbank for driftwood and chips, which were "dried and used for making the lone fire which none too frequently burned in our home," he wrote. The family's tinderbox that contained flint, steel and tinder was used to start a fire in the house because "sulphur matches were far too scarce and expensive."

Samuel experienced hunger pangs that "subjected" him to fainting spells. "Mother would not let me leave the house unless I had some hot coffee and bread or hot soup," he wrote. Other symptoms required more extensive bed rest. (In later years in America, Samuel would make frequent trips to take the healing thermal waters in Baden-Baden, near Germany's Black Forest, and as a merchant, he worked diligently to not let his afflictions impair the family business.)

The child held close to his heart the father whom he adored, had walked with and anticipated greeting at the landing. Fortunately, Samuel was very young. Considered a "sensible and watchful child," aspects of his new life were filled with stories of home and adventures that buoyed, entertained and helped shape him. Remarkably, he retained his Fordon experiences with near-photographic precision and later wrote his life story recalled from memory and notes.

His days of hunger led to a persistent, marketable regard for food, its preparation, color, texture, taste, availability and costs. He accounted for this in writing, and "as a result he developed a life-long frugality and kept meticulous accounts to which he referred even after he had become a wealthy businessman and property owner," wrote Judith Robinson in *Utah Pioneer Merchant*.[4]

Samuel's memoirs contain multiple drafts, edits and revisions that dazzle with quick pitapat tales about sailors, heroes, superstitions, ice floes and river floods.

RAUCOUS SAILORS AND RIBALD TALES

Dropping anchor midstream near the town of Fordon, crewmen would unlash their canoes and row ashore to trade goods, purchase supplies, maybe wash at a fountain and frequent the tavern for food and drink. During those times, Samuel and his friends would rush to the outriggers, untie them and, in acts of maritime piracy, paddle along the shoreline and shadows for what seemed like hours. Hearing the alarm sounded by an underling stationed as lookout, they'd paddle furiously and retie the canoes to the original landing, none the worse for wear.

The river men were seasoned sailors, ofttimes ill kempt, wiry ("or stout and clad in the crudest and roughest of clothing," Samuel added) and rowdy. Loitering in the town's cobblestone square and loose-tongued by liquor, they regaled the wide-eyed lads with hair-raising tales of deeds and misadventures. Tough smugglers, habitually bootlegging tobacco, alcohol, butter, spices and other contraband from Russia, would stop their illegal activities to up the ante with terrifying tales of life-and-death risks, near escapes and fierce fights with federal officers.

Samuel enjoyed hearing the coarse adventures, but early on, after showing an interest in "merchandising, farm production, and food stuffs of all kinds" being touted at a trade fair he attended with his uncle Friedman, he discovered traveling merchants and peddlers as unrivaled artists in pleasing both young and old audiences with their oratory skill and timing. "As a small boy it was my greatest delight to hear them speak of their experiences," he wrote. "Some had traveled great distances all over Europe and beyond into Asia and their fascinating tales, and how they related to others, were part of their stock-in-trade."

VISIONARY PREDICTIONS
AND THE FRENCH INVASION OF RUSSIA

Fordon was steeped in superstitious or historical and dramatic episodes: the telling of times when horrific fires felled the town's many wooden buildings; massive floods nearly drowned the town; epidemics were no strangers; witch trials were common (from 1675 to 1747, seventy-three people were accused of the "Devil's magic"); and massive flocks of silk-tailed winter thrushes, known as visionaries, predicted "famine, pestilence, or war."

According to Samuel's mother, such foretelling was of import to Napoleon Bonaparte, who, in 1812, was in her city on his way with his troops to invade Moscow. Bertha spoke glowingly of Bonaparte, a Roman Catholic, "whom she [adored] and saw with her very own eyes," her son wrote. Unmoved by criticism (some say Napoleon strived to liberate and integrate Jews as equals; others contend he simply wanted numbers in support of his campaigns), she may have wondered about his culpability when coming face-to-face with and ignoring the small berry-loving "birds of disaster."

En route to Russia, "Napoleon came to our town from Thorn to supervise the crossing on pontoon bridges at Fordon and the transportation of his troops and supplies upon the River Vistula," Samuel wrote.

Visibly agitated and reportedly depressed by the recurring sight of the birds, it seemed nothing could deter him from his late-season undertaking. Even warnings by the town's revered rabbi, who "begged" him to delay his invasion and warned of winters far too bone chilling and severe for the French soldiers to tolerate, fell on deaf ears.

"Napoleon proceeded on to Moscow where he expected to quarter his troops during the winter," Samuel wrote. Arriving on September 14, 1812, Napoleon entered the mostly deserted city. "After removing all the provisions, the Russians had set fire to the city, leaving only ruins and ashes," Samuel wrote. Unable to advance, Napoleon remained for four weeks before retreating into the severe cold and deep snow. His men were harassed, shot at and pursued by Russian troops; and winter took its toll. By January 1813, trails of blood and human loss defined Napoleon's ruinous retreat and failed invasion.

More than 400,000 Frenchmen, Poles, Italians, Germans and other nationalities were lost, of whom "many had their feet and hands frozen, and many, many thousands more perished miserably along the way, to sleep their last sleep in an alien land," Samuel wrote.

ICE FLOES, FLOODS AND DAMAGE

Fordon's winters often began early and were bitterly cold and menacing. When enormous icebergs from the high country flowed downriver and came to loggerheads with other ice wreckage, they turned the Vistula River into frozen gridlocks.

For several months every year, business for all commercial river enterprises was at a standstill and the local ferry service was canceled. But the need to cross the river was constant. After measuring the thick ice field for depth

and stability, town inspectors called on workmen to bore holes deep enough to lodge large upright pine limbs. Spanning the frozen-solid wide waterway from bank to bank, the boulevard of stalwart forestry marked safe crossing for pedestrians and wagons.

"I had seen twenty wagons, each loaded with twenty sacks of wheat weighing one hundred pounds apiece, hauled by teams of four strong horses, make it safely across the ice," Samuel wrote. "Owners of estates and ordinary citizens would haul across the ice farm produce, wheat, rye, oats, barley, and other products toward the city of Bromberg and return [by the same route] carrying machinery and other supplies, saving the expense of having them ferried when the river was open for navigation."

A seasonally strong ice river, in April 1854 a spring's thaw and randomly dissolving icebergs nearly drowned Fordon. "Twenty-feet-tall melting icebergs and snows from the Carpathian mountains and adjoining watersheds caused the Vistula to rise," Samuel wrote.

Flashfloods ravaged the town's riverbanks. Maverick waters consumed lower parts of the city near the marketplace, pushed into basements and surged forward, taking with them weakened homesteads, livestock, stables and people.

"Forests of tree branches still standing upright in [cubes of] frozen ice came floating down the river," Samuel wrote. "People by the hundreds gathered along the shoreline with ropes and long poles and worked frantically to save hapless human beings and cattle. But some were too far in the center of the river. It was heart-rending to see people go to their death and no help could be given to them."

The ice floe created a formidable threat to structural sites. "Large bridges built of heavy masonry and iron girders were swept away as if they had been made of paper. It was futile to put a boat in the raging water because the floating ice would invariably crush it."

Fortunate villagers carried furniture and personal belongings up to higher ground. Less fortunate others lost most or all of their homes and farmlands. Those dealing with the littered debris of what had been theirs became impoverished.

In time, the waters receded, the river resumed its swift and navigable flow and for those who relied on the Vistula for personal or commercial transportation, it was back to business.

The river's course continued to stir Samuel's dreams of change that would eventually lead him to America—as it had his brothers Frederick and Theodore, whom he would later join in California.

Part II

A BECKONING
FOR FREDERICK

APPEALING TO A PROTECTIVE ANGEL

CONTRIBUTING TO THEIR SUPPORT

Born in 1836, Frederick Hillel Auerbach was fifteen years old when his father died. Earlier, he had been apprenticed out to a grocery store owner in the nearby city of Bromberg, where it was hoped he would learn a trade, become self-sufficient and contribute to the family coffers.

Instead, his work experience was marred by indentured servitude. There was no fire lit in the store for warmth, and during the winter months, he could not keep himself from shivering and his fingers were often swollen and close to being frostbitten. Although it was a miserable arrangement, his work ethic strengthened his character. He worked diligently and bought hot, salty rye rolls with caraway seeds for pennies, but given barely enough to eat, as promised by his mentor, and unable to escape the cold, he finally had to quit.

His next apprenticeship took him to the city of Culm in the lowlands of the Vistula and to Mr. Sternberger, who owned a leather and shoe business. Sternberger, pleased with Frederick's work and ambition, gave the likeable sixteen-year-old his own room, in which after hours he could study, and supplied him with enough food to satisfy a growing teenager.

When Frederick was a student at the local school in Fordon, one of his teachers, Mr. Lowenthal, thought him clever and volunteered private English lessons and made accessible many books from his massive library. Inspired by books on America, Frederick believed he might realize his economic aspirations in a challenging new society. So much so that

after being in Sternberger's employ for two years, he was frustrated and determined to make a change. Writing a letter to his father's nephew Louis Auerbach in Berlin, the young man described his family's poor condition and asked for assistance and a loan of "sufficient money to immigrate to America."

Louis Auerbach was an influential and wealthy merchant and exporter of silks. Frederick was uncertain about his cousin's reaction—they had rarely corresponded, and he was over the moon when Louis invited him to Berlin with a promise to help him reach America.

Frederick then had to plead with Sternberger to be released from his contracted apprenticeship. "He told him his widowed mother and family were dependent upon him and that he wished to go to America where he could earn larger wages and contribute more to their support," Samuel wrote. "His master, however, not only refused to release him, he threatened to send after him a gendarme with pistols and a saber on horseback unless he returned to work."

Fortunately for Frederick, a townswoman who initially recommended him to Sternberger spoke on his behalf, deeming his words were indeed genuine. "To my brother's surprise, Sternberger not only relented but sent him his final wages and an extra five *thaler* [silver coins] to help him on his way," Samuel wrote.

THE FIRST STEP TAKEN

In July 1854, Frederick went to Berlin and was greeted warmly into his cousin's home. Louis, true to his word, loaned the young man fifty *thaler* for his passage. He handed him an introductory letter for family friends and relatives in New York, a passport to cross over borders and a work document to show customs officers that he was a "traveling representative" of his uncle's company. "Without the document he could not have left the country," Samuel wrote. Although Frederick was not tall enough to do military duty as a soldier, he was eligible for compulsory military service.

With his papers in good order, eighteen-year-old Frederick traveled to Hamburg and boarded a small sailing vessel. The voyage was rough and long. Forty-nine days later, he landed in New York.

"We did not hear from him for some time, and we waited and prayed for him," Samuel wrote. "Our poor mother did a lot of crying when he left and looked forward to seeing the letter carrier every day. We all did. We didn't

have the courage to ask, 'Have you a letter for us? Is he alive yet?' If prayer and fasting would appeal to a protecting angel, he surely had protection."

When Frederick's letter arrived telling of his safety and well-being, Bertha "cried with relief."

Fredrick repaid his cousin and his master "many times over." He wrote letters home, faithfully supported his mother and, later, feeling responsible for the well-being of his siblings and their children, provided them opportunities to come to America.

No longer indentured, Frederick honed his instincts to what lay ahead.

MASTER OF HIS FATE

M y brother was a remarkable man. He had a common school education. Was studious. Did a great deal of reading by the oil lamp light and was well up in Hebrew, Yiddish and German by the time he left for New York," Samuel wrote.

Arriving in the historic city of Newburgh on the Hudson River, Frederick met his uncle, Jacob Tobias, and was given lodging and a clerk's job in his clothing store.

Jacob Tobias remembered Hillel and his family. When Tobias was a teenager, he had visited Fordon, stayed with Hillel and Bertha, and never forgot the kindness they extended by purchasing him new clothing and boots and sending him to school. Later, when Tobias moved to England, he met and married his dear Charlotte, the daughter of a physician. Together, they immigrated to New York.

Frederick was determined to be the master of his fate. He desired to improve the quality of his life and that of his family left behind in Europe. And he was driven not only to read in English and speak the language fluently but also to understand the nuances that shaped this new country and its citizenry. Every evening after work, Charlotte and he sat down at the dining room table for rounds of English lessons, and eventually Frederick spoke flawless English with little or no accent.

"When Uncle Tobias opened another store selling clothing, furnishings and goods, he offered it to Fred to operate upon a half-profit basis," Samuel wrote. "Fred remained in Newburgh, New York, for nearly two years. By

1856, his finances were now such that he felt he could at last continue on his projected journey to California."

California's "world-class" gold fields had sparked the largest mass migration of gold seekers from around the country. Although the get-rich-quick-and-go-home scheme was a pipedream for many, profits from boomtowns stimulated the country's economy, and the clarion call for all available goods and services was heard loud and clear.

In early spring, Frederick, grateful for his uncle's help and Charlotte's tutoring, left his relative's employ and sailed around Cape Horn in southern Chile's Tierra del Fuego archipelago to California. It was a challenging six-month voyage from the port of New York, encompassing more than fourteen thousand miles of rough storms, strong winds and seasickness, with the lack of fresh food evident soon after the first week onboard.

"The boat put in at Rio de Janeiro, Brazil; Valparaiso, Chile; Panama; and Acapulco, Mexico before landing in San Francisco in the fall of 1856," Samuel wrote.

Frederick fell severely ill at sea with tropical fever, an infectious disease with potentially debilitating or lethal consequences. He was fortunate to befriend the ship's barber, who, performing his secondary duties as a surgeon, pulled him through. Regaining his strength while recuperating in San Francisco, Frederick then spent several months of research working at a wholesale mercantile company before looking into setting up a tent store in mining camps and catering to the influx of miners and their needs.

He traveled to the boomtown of Bodie, California, about seventy-five miles southeast of Lake Tahoe, where he partnered with a landsman named Alexander Lowenberg and set up a store. Business was active when Frederick, hearing about Rabbit Creek and its more progressive gold diggings, decided to move on.

"Fred engaged in the mercantile and mining business, his first store in Rabbit Creek being in a tent," wrote Samuel. No doubt gold fever was in the western air, and it exuded potential. Samuel, waiting for his turn, yearned to fit in.

TOO GOOD TO BE TRUE

Samuel Prepares

Living at home, thirteen-year-old Samuel was apprenticed to a furrier to learn the tanning and preparation processes of leather and furs. Unsuccessful in the effort, he later wrote that the experience stood him in good stead when the brothers engaged in the fur trade on the western frontier.

Another apprenticeship offer took him to the town of Culmsee, where his aunt Sarah Levy's sons, skilled tailors, were prepared to show him the subtleties of tailoring. Declining the position, Samuel wrote that sewing "did not just suit" him, but that, too, was appreciated later when he relied on numbers of Indian tanned skins, Auerbach's in-house seamstresses and the burgeoning cottage industry for women in the West to produce thousands of buckskin gloves and embellish felt hats bought and sold in their stores.

"When my brother Fred wrote asking me to join him in America, it seemed too good to be true," Samuel wrote. "I was thrilled although hated to leave my mother and my sisters. I do recall I was the envy of all my playmates."

Samuel had paper booklets illustrating "thrilling and exciting stories of Indian warfare, feathered caps, bows and arrows, and tomahawks." When not borrowing canoes from sailors, he and his young friends hunted buffalo and bear along the river trail, with a big shaggy dog cast as one creature or the other. Digging for gold and coming up empty handed, the boys begged Samuel to send them everything he found in the New World, from gold nuggets to buffalo robes and bear rugs.

Frederick hired his former teacher, Mr. Lowenthal, to tutor English to Samuel and his sisters. "From that day on, English had a particular attraction and fascination for me. It was in truth a magical language, and we embraced it," Samuel wrote. "My teacher asked me to write him from time to time describing the country and the people and life there, as well as my experience. He urged me to keep a diary of the more important and interesting events. It was due largely to his suggestions that I made many of the notes and entries upon which my memoirs are founded."

(Beholden to Lowenthal, who helped them master rudimentary English, the brothers regularly sent money to him during his lifetime and, after his death, to his widow.)

In 1862, before Samuel left home, he visited his sister Rebecca and said a long goodbye. They were close siblings. Wishing him to stay, Rebecca told him instead to follow his heart. He later wrote it was his "pride" that made him go—but at fifteen years old, most likely that emotion was interwoven with a passionate sense of adventure.

First Things First

Samuel needed to get a passport in Bromberg, "an important German strategic center on the Prussian frontier." Unable to afford to hire a carriage, he and his mother walked the twelve miles to the center, where he received the necessary documents and then walked home. Several days later, Bromberg loomed again as a first step to America, and fortunately, Samuel caught a ride on a wagon.

Embracing her son goodbye, Bertha said, "God speed." She reminded him to "leave drink, cards and women alone and all will be well with you." She added: "Don't let anyone pour three dew drops of water over your head, always remain a Jew, and when you have fulfilled your life on this earth and the end comes, they will bury you on a Jewish God's acre." And she advised, "I know you will do business on Saturdays and smoke and work and not hold the ritual with the food but you will always stay a Jew."[5]

Sails and Steerage

Joined by his adventurous older cousin Simon Levy, Samuel boarded a fourth-class railway carriage—"the very cheapest railway ticket to be

had"—and headed to Berlin. From there, they rode the train to the Port of Hamburg on the Elbe River and waited to embark on the Hamburg-American Line's three-mast steamship *Borussia.*

"That beautiful harbor known as the 'Gateway to the World' will always remain in my memory," he enthused. "I was bewildered by the thousands of high masts and riggings of the sailing vessels and steamers. The masts were so numerous I could scarcely see the light through them. It looked like a great forest."

Samuel walked along Hamburg's "principal business streets" and, putting pen to paper, detailed streets crowded with elaborate shops framed by exquisite window displays. He compiled a meticulous list of purchases for the sea journey: "Mattress, pillow stuffed with straw, blanket, bottle of raspberry syrup, tin cup, knife, fork, spoon and some articles of food."

He described the steamer *Borussia*, powered by screw propellers, as "small, about 2000 tons," with steerage bunks "narrow, cramp and crude" and steerage quarters as "congested, dark, dingy, dimly lighted by faint-flamed lanterns that were poorly ventilated and ill smelling." The food often consisted of "bread, vegetables and occasionally a very little piece of meat." After a few days at sea, he noted the potable water was "stale."

The ship's passengers, mostly emigrants, remained on deck whenever possible. "But the little deck space allotted to the steerage passengers was littered with chests, boxes, barrels, coiled ropes, so it too was always congested," he wrote. "For several days I was very seasick, homesick, too; and as the great waves beat against the boat, pitching it about, I could not help but ponder that only a few lumber planks separated me from the wild sea."

After the ship had weathered two storms, heavy fog and looming icebergs, Long Island finally came into view like a breath of fresh air. While the steamer barreled toward the barrier spit at Sandy Hook, passengers were told to toss their mattresses and pillows overboard. "To destroy these things, miserable though they were, seemed such a shame to me," Samuel reflected.

After seventeen days at sea, Samuel landed in New York Harbor and into quarantine. He had in his possession some copper and silver coins and, "treasure of treasures," a can of sardines.

Chapter 6

NEW YORK, NEW YORK:
A MARTIAL TOWN

T he waters around New York were crowded with noisy tugs, ferryboats, countless sailing vessels, clipper ships, river craft, ocean steam boats, and many packet sailing ships," Samuel wrote. On land, it was a sea of people.

Samuel arrived during the early phases of the American Civil War (1861–65). New York was a martial city dotted with army tents, soldiers and potential draftees lining the streets. No sooner had the emigrants disembarked from Europe than appeals for Union recruitment ran rampant and the air was abuzz with offers of monetary incentives.

"Soldiers were constantly marching up and down the streets and to and from the ferries to the sound of fife and drum music. I was in a fever of excitement and thought it was glorious," the youth recalled.

Still a teenager, Samuel was enthralled by reading tales of swashbuckling pirates, treasures chests, pieces of silver and the gold fields of California, but he was profoundly disturbed having learned about the slave trader Captain Nathaniel Gordon and his odious exploits of human trafficking and the heinous acts that stripped and dehumanized black men, women and children. "Where I came from [the act of human] slavery was unknown," he wrote. "The incidents by the slave trader and the unthinkable matter of buying and selling human beings like cattle made a profound impression on me."

In August 1860, Captain Gordon and his slave ship *Erie* were captured by the USS *Mohican* on the Congo River in West Africa with nearly nine

hundred slaves, half of them children, packed tightly and suffocating below deck. The surviving few were freed and resettled in Liberia, an independent American colony established by the American Colonization Society. In a New York court, Judge William Shipman pronounced judgment against the slaver under the 1820 Piracy Act.

"Do not flatter yourself that because they belonged to a different race, your guilt is therefore lessened," the judge said. "You are soon to be confronted with the terrible consequences of your crime."

The first and only slave trader to be tried and convicted, Gordon was sentenced to death by execution on February 21, 1862. The night before, the prisoner attempted to take his life with strychnine but was revived and hanged earlier than planned the next day.[6]

So Much to See

Samuel, whose expenses were covered by his brother Frederick, had in his pocket an introductory letter to Mr. J. Lesser, a shoemaker, who brought him to a boardinghouse on East Broadway. There, paying $1.50 a week, his residence for nearly a month was a very small room on the top floor tucked under the eaves. He thought it "glorious," topped only by a sampling of white bread for the first time, declaring that it "certainly tasted marvelous."

From sunup to sundown's waning light, Samuel explored the city, tallied costs from events to excursions and ate up historical facts. "Broadway was the show place of New York," he wrote, looking skyward at nine-story-high brick buildings. The Bowery District on lower Manhattan was star-studded with popular theaters and concert halls and lively with beer gardens, pawnshops, flophouses and brothels. Canal Street was flooded with retail stores and abundant offices that piqued his sense of business needs and, again and again, design, placement and sales. The elegance of Fifth Avenue's choice residential section and the splendid homes of Lafayette Place, Washington Square and Union Square gave him pause.

From the spire of the Trinity Church, Samuel got a "bird's eye glimpse of New York" and its many emporiums, markets, jewelry concerns and dry goods establishments that were vigorously trading with the populace. He couldn't afford to eat at Delmonico's, New York's "first a la carte restaurant," not then, but since food and costs were always on his mind, he did peek inside. He spent days rambling through the 448-acre Central Park, America's first landscaped public park, designed by renowned architect-

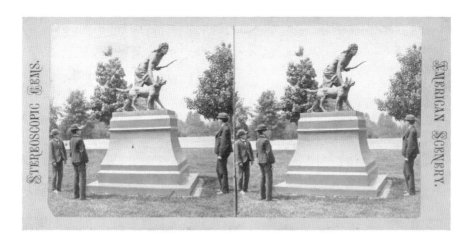

Above: *The Indian Hunter* sculpture by John Quincy Adams Ward, Central Park, New York, cast in 1866, dedicated on February 4, 1869. *Library of Congress.*

Right: Writing home. *Herbert Auerbach Collection, Marriott Library, University of Utah.*

in-chief, co-designer and conservation activist Frederick Law Olmsted. He rode on stage lines, horse cars and ferryboats and stood when "the car was crowded to overflowing." He walked miles by foot. By the end of his tour, he had mapped the urban park city and memorized its "characteristics," just as he had done in Fordon.

"I noted with interest that in hotels and lounging places it was customary for many people to tilt their chairs against the wall and recline with their feet stuck up on railings or other chairs," he wrote. "I had never seen anything like that before."

Samuel stressed composing such information and entertaining the mind as essentials to understanding and building one's character and livelihood. Years later, he would counsel his children to compose meaningful words flush with detail.

To young son George in 1899, Samuel wrote, "Your [recent] letters consisting of few lines are very, very nice but short. If you write often you will get used to [writing more] and it will be easy for you to write a good letter. Write on any subject. It does not matter what. But take time and write it well. With love to everybody."[7]

INTOXICATING COLORS AND SCENTS

A TROPICAL PARADISE

Samuel's cousin Simon found employment as a tailor and decided to stay in New York. On July 21, 1862, however, Samuel sailed out of the harbor on a side-wheeler to San Francisco by way of the Isthmus of Panama.

The steerage ticket west was about eighty dollars, a cost "almost doubled from San Francisco to New York over land," he wrote. The steamer carrying over six hundred passengers was "badly over-crowded" and laden with "boxes, barrels, machinery, and tools such as picks and shovels, hatchets, and axes strewn upon the deck and in most other available spaces." Hordes of people waved from the dock and shouted, "Good luck!" "Safe voyage!" "Send some gold home!"

"As we steamed out down the river and bay, the city spread out in a wonderful picture that still remains one of the most beautiful within my recollection," Samuel wrote.

During the ten-day voyage from New York to Panama, the captain and crew stood alert for signs of Confederate ships and blockade runners carrying weapons and war cargo. Sailing through the West Indies, past Cuba and Haiti, they neared the Isthmus of Panama and docked in the seaport town of Colón. There, the once invigorating sea air of the Caribbean Sea turned stifling.

Colón was also named Aspinwall after William Henry Aspinwall, founder of Pacific Mail Steamship Company and one of the builders of the Panama Railroad that carried post and men coast to coast. The 47½-mile-long "Iron

Road," also called the "inter-oceanic railroad," ran parallel to the Panama Canal and took over five years to complete (in January 1855), at a cost of $8 million and upward of ten thousand deaths.

"Yellow fever, cholera and malaria were prevalent upon the Isthmus, and the water was undrinkable," Samuel wrote.

But thousands of 49ers took to the rails as a shorter and more direct route through Panama's dense jungle to the ephemeral pot of gold in California. The railroad remained profitable, charging up to twenty-five dollars for a one-way ticket on an often-replaced hard-laid track.

"At first the train proceeded very slowly, as the roadbed was in poor condition and the ground all about was low and swampy, the water frequently standing up to and over the top of the rails," Samuel wrote. "This slow speed, however, afforded me the better opportunity to see the country through which we were passing."

In the overpowering heat, sweat "streamed" down Samuel's face and drenched his clothes. But in the mesmerizing climate, he forgot all creature comforts, so intrigued was he with the country's humanity, agriculture, flora and fauna. "Jamaican negroes and natives of mixed Indian, Spanish and African descent were selling dried meat, tropical fruits, flowers, shells, and coconuts," he wrote. "The oranges and bananas were particularly fine, the weather hot and sultry, and I tasted my first sugar cane."

The native soldiers carrying "rusty sabers or guns, and wearing dirty white pants and shirts, and ragged hats of all styles and colors," he wrote, made a striking contrast to "very precise and neatly dressed Prussian soldiers I was accustomed to seeing."

The jungle's abundant and colorful fashion palette was dense and lavish. "Parrots, macaws, toucans and other birds and butterflies of every conceivable color abounded and varieties of monkeys jumped and played about in trees," Samuel recorded. "It was all so interesting, time passed quickly into moments before seeing the Pacific Ocean, and the quaint and beautifully situated city of Panama."

Whitewashed buildings, thick walls and red-tiled roofs looked like textured paintings. Tropical forests that threw saturated shadows like elaborate finger-weight lace, cathedrals that shimmered like sun-struck jewels and shabby hotel restaurants serving memorable "tasty fish, chocolate and fried cakes" stirred his senses.

For the thousands of gold seekers, though, many were stranded for weeks at a time, unable to secure passage on the rarely scheduled and always overcrowded ship. "Several men tried to buy my ticket, offering an attractive

premium," Samuel wrote before he boarded the *Orizaba*, a 1,300-ton, wooden side-wheeler built in 1854, belonging to the Pacific Mail Steamship Company and loaded to the gills with freight and passengers.

"The creaking and groaning of her timbers was terrifying," Samuel wrote, "[but] the sailors said that rats invariably forsake a doomed ship and judging by that standard the *Orizaba* must have been the safest boat in the Pacific."

Biscuits, pilot bread and water-crackers with maritime roots in hardtack were accompanied by coffee or tea and brown cane sugar that "for all the world looked like sand," Samuel wrote. "At home, sugar was very expensive and a great luxury so it seemed incredible to be given such large rations of this precious sweet."

Meals of corned beef and pork, mackerel and boiled Peruvian potatoes made his mouth water. "They [the potatoes] were purplish-looking, cooked in the jacket and more delicious tasting than I had ever eaten."

Dining while standing at tables suspended from the ceilings by iron rods that could be swung back up and latched, Samuel happened to pass by the first-class dining room. There, platters of fresh fruits and delicacies heavily weighted the linen-covered tables. Wondering if he would ever be able to travel first class, Samuel decided there and then that he would.

The *Orizaba* sailed slowly out of the Gulf of Panama and, following along the coast of Costa Rica and Nicaragua to Guatemala, traveled at night without lights. "Our captain had been warned that the Confederate steamers *Alabama* and *Ariel* were cruising the Pacific on the lookout for northern boats," Samuel explained. The CSS *Alabama*, known to "steam from 12 to 13 knots an hour" and equipped with cannons and a crew of over one hundred, was said to have been constructed in secrecy by British shipbuilders near Liverpool and identified simply as "hull number 290."

Throughout the voyage, Samuel acquainted himself with the cultures of others. He saw young native swimmers dive into deep waters to retrieve coins "thrown in by passengers." He inhaled the intoxicating aromas of tropical plants, passed by old forts and waited while cattle and live fowl were taken on board for food.

He attended a sea funeral for a man "wrapped in a sheet of canvas weighted at the feet and laid upon a plank." After a simple service, "the plank was placed upon the rail, and tilted so the body simply slid into the briny deep.

"I was deeply impressed by this sea burial, and particularly with the thought this person was buried so far from home and in a place never to be visited by family or friends," Samuel wrote. "I experienced a severe spell of depression and homesickness."

ANOTHER BACKDROP

Samuel was often homesick but so intrigued with such scenes and experiences that he was insatiable. On August 17, 1862, the exhausted teenager landed in San Francisco, slept for a few days, felt the bite and itch of the "California flea" and walked the cobblestone streets of the city. He discovered jobbing houses (wholesale merchant businesses) on Front, Battery and California Streets; retail dry goods stores and curb brokers (stockbrokers who "bought and sold" securities on Sacramento Street, usually after the stock exchange has closed); and a trail of saloons, dives, gambling houses and dance halls on Pacific and Jackson Streets.

Crowded into a riverboat en route to Sacramento, Samuel listened to rough-looking men, "sitting, squatting, and lounging upon boxes and barrels talking about gold diggings, rich strikes and mining experiences some of which were very wild."

After breakfasting in Sacramento, the western terminus of the Pony Express, Samuel boarded the stagecoach to Marysville, in Yuba County.

Called the "Gateway to the Gold Fields," Marysville was one of California's largest cities. In 1857 alone, its banks shipped more than $10 million in gold to the U.S. Mint in San Francisco, and its city founders envisioned Marysville becoming the "New York of the Pacific." But debris from hydraulic mining, which threatened the watershed land and choked the rising riverbeds to overflowing, eventually sealed its fate.

Leaving Marysville on an early stagecoach the next morning, the sixty-mile ride to Rabbit Creek took the passengers across a lush countryside with dense trees, bushes and shrubs. Encountering steep hills, the travelers would alight from the coach to lessen the load and walk, sometimes laboriously. "One hill rejoiced in the name of 'Push Stage Hill,'" Samuel remembered.

THE LAST LEG

Near ten o'clock at night, the stagecoach pulled into the station at Union Hotel, where Frederick waited to greet his brother. Eager to catch up on news about their mother, sisters, relatives, friends and neighbors, the brothers talked for hours; the following morning, Theodore joined them.

"To my great delight, Theodore came to meet me from their store in the [nearby gold camp of] Port Wine. I recall vividly that he gave me a silver

dollar to buy peaches, which were selling at twenty-five cents each. That big silver dollar seemed a fortune to me. I looked longingly at the marvelous peaches, the largest and most beautiful that I had ever beheld, but I saved the dollar," Samuel noted.

Part III

GLEANING
OPPORTUNITIES

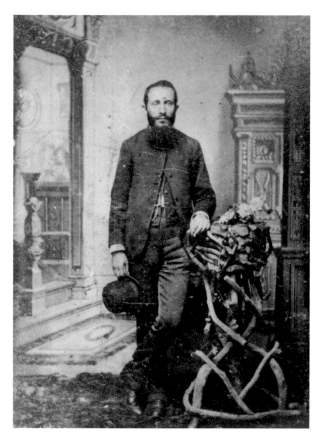

An 1860s studio shot of Frederick Auerbach (unverified). *Herbert Auerbach Collection, Marriott Library, University of Utah.*

Chapter 8

THE MIDDLE SON

Theodore Auerbach. *Herbert Auerbach Collection, Marriott Library, University of Utah.*

Theodore was short, husky and, like his father, Hillel Tobias Auerbach, very strong. Tutored in English, he apprenticed early to learn the cigar trade and, aided by relatives, left Fordon in 1858 for New York. Working in the manufacture of cigars, a profitable assembly line business he would revisit over the years, Theodore joined Frederick, traveled to the Far West and together helped build retail branch stores, form partnerships and work with bankers. Having the wherewithal of the business trade, Theodore also knew how to ride mules and horses and handle a gun. He appeared fearless carrying gold dust in a robber's clime. No doubt, Theodore was an able contender on the American West frontier.

Chapter 9

GOLDEN DREAMS

R abbit Creek played out Samuel's boyhood dreams to the fullest. Smitten with the Wild West, all its trappings and the eclectic pursuit of gold, mercantile and mines, Samuel eagerly took to the rigors of frontier life and continued to learn English.

A MATTER OF BUSINESS

Rabbit Creek was settled in 1850 and officially renamed La Porte in 1857 but was resolute in maintaining its original mantle. The town was the trading headquarters for thousands of miners scattered throughout numerous mining camps and was known as one of the "great placer-mining districts of the state," with rich yields. Between 1855 and 1871, the area produced an estimated output of $60 million.

"It was a real boom mining camp, with all it[s] absorbingly interesting life and activity. Some of the principal camps in the vicinity rejoiced in the euphonious names, including Port Wine, Whiskey Diggings, Poker Flat, Wahoo, American House and Poor Man's Creek," Samuel wrote.

The similarities of setting up tent shops at trade fairs, like those the brothers attended with their uncle in Prussia, may have fashioned the schematics and the nuts and bolts of setting up the temporary tent stores the Auerbachs replicated throughout mining camps and towns and along the western railroad lines.

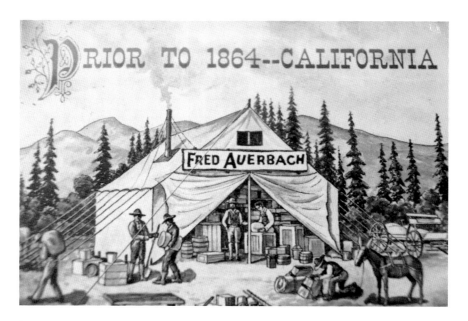

Setting up a tent store in a boomtown. *Herbert Auerbach Collection, Marriott Library, University of Utah.*

Canvas tents could be quickly pitched (and taken down). Pairs of opened and opposing ladders supporting long boards between their rungs became tiers of display shelves stocked with merchandise. Emptied wooden shipping crates stacked on their sides evolved into sales counters and improvised stockrooms. As standalones, they made excellent chairs. Exterior canvas covers fastened to the tents protected goods and people from rain, dirt, dust and the bright western sun.

Frederick and Theodore opened three stores in Rabbit Creek. They expanded from a canvas tent store to one made of wood and then constructed a large brick and rock establishment that exuded stability in the surrounding mining district of southern Plumas County.

They sold quantities of merchandise to both "commission merchants and merchants in Virginia City, Nevada; Virginia City, Montana; Helena, Montana; Fort Benton, Montana; Great Salt Lake City, Utah and Fort Bridger, Utah," Samuel explained.

Between 1860 and 1878, the three brothers opened branch stores in Bryan, Wyoming; and Ogden, Promontory, Corinne, Pine Canyon and Silver Reef, Utah. While in Rabbit Creek, Theodore spent much time at their store in Port Wine, located "downhill two miles and up one." The store was called Lavenberg & Company. "We were the 'Company,'" Samuel noted.

Theodore was also a messenger for Rabbit Creek's John Conly & Co. Bankers, which in 1858 installed one of the first fireproof banking offices in the area and whose holdings were later robbed three times by California stagecoach robber Charles E. Boles, aka Black Bart. A prospector as well, Boles is known for robbing twenty-eight stagecoaches of their strongboxes in northern California, southern Oregon and the Siskiyou Trail in between. He never harmed a passenger and often left a poem or two at the crime site. When Samuel sailed into San Francisco in August 1862, Bolles was serving in the 116th Illinois Regiment. He fought in many battles, was wounded, honorably discharged and began farming. By 1875, he "politely" returned to robbing.

"Conly bought considerable gold dust, and [hired] a number of guards to accompany Theodore, who would carry it from Port Wine to Rabbit Creek and other camps at intervals until reaching the City of Marysville," Samuel explained.

"Theodore had a Mexican saddle and rode a large mule. He had a pistol box in front (in which the gold dust was carried) and a large pistol on each side. When the bank sent large quantities of gold bars or gold dust to Marysville, Theodore was in charge as the messenger. The bank managers would charter a stagecoach and extra men armed with sawed-off shotguns on top of the stage to guard the treasure. It's a wonder Theodore didn't get hurt."

Theodore didn't—not by bullets.

Chapter 10

A PROTOTYPE FOR THE FUTURE

Continuing to build up their store, Frederick envisioned it as a prototype: to serve more people with more goods and a diversity of wares. Auerbach's on Rabbit Creek's busy Main Street carried a general line of dry goods, such as sugar, tea, coffee, flour, bolts of textiles, ready-to-wear clothing, woolens, linen, silk, furs, hats, boots, shoes, blankets, mattresses, notions, laces, buttons, candles, tallow, carpets and wallpaper. It stocked medicinal drugs and elixirs and sold mining and farming equipment, hardware and sundry supplies and dried, preserved and fresh meats, and groceries. Saddle trains and pack mules carrying mail-order purchases made weekly trips to surrounding mining communities within a twenty-mile radius.

"We specialized in men's and ladies' Indian tanned buckskin gloves, with cuffs—some in beaver—embroidered with silk in fancy floral design and sold beaver overcoats, doeskin pants and coats in great quantity," Samuel wrote. "Merchandise exchanged for fresh goods—butter and eggs—would be sent to places like Virginia City, Nevada, where they could be disposed of for gold coin."

Like most merchants, Frederick and Samuel slept in the rear of the store as a way to protect both the store and its inventory. Brick buildings were claimed to be fireproof. In wooden structures, sand barrels were placed by cellar doors and used to extinguish flames.

"Each store had a wooden porch in front to protect it against the snow, which in winter fell to a great depth," Samuel remembered. "The snow would be shoveled from the porch into the street, which caused high piles

of snow to accumulate. We often tunneled through the snow to get to the other side."

Auerbach's busiest hours were on Saturdays and Sundays when people flooded into town for supplies and entertainment. In addition to the store's myriad goods, products and produce, it served as a gathering place for "the boys," those gold miners who discovered Auerbach's open and trusting environment ideal for relating the day's events, mulling over ongoing miners' strikes, bringing one up to date about the war, reading family letters and reciting homilies.

When the promising personal booms that would see them homeward bound went bust and prevented them from writing home, "many of the boys drifted further and further away from their folks and loved ones as they were ashamed to return because they had not made their fortunes and could not report success," Samuel wrote. "Some of their stories were indeed pitiful. Mothers, wives, sweethearts and sisters suddenly failed to receive mail from a loved one. Sometimes a man may have been executed for some misdeed, but the ones at home would never know for the boy's fellow workers religiously refrained from sending such news to the folks of the dead man."

Loneliness, solitude, homesickness and mining hardships with no guarantee of finding gold weakened the resolve of many gold seekers. A miner who did strike gold and was preparing to go home might find himself "trying his luck at a gaming table and lose his entire fortune," Samuel wrote. "Then it was back to the diggings again with only dreams of seeing his loved ones that in all probability he never would see again."

A PINCH OF GOLD DUST EQUITY

The store was a continual training ground for young Samuel. After a friend and customer said he could buy a pair of "Marysville Mills red-flannel underwear" elsewhere for less than what Auerbach's charged, Samuel bet a ten-dollar gold piece that he couldn't and lost.

"I was too positive that there was a restricted selling price on those goods," he wrote, "and betting ten dollars was a good investment. It showed me the necessity of investigating and proving everything before accepting anything for positive."

Currency was ambiguous. Minted (manufactured) money was rarely used, and paper money was not considered worth its face value. Most transactions were made on credit, trade or barter or with gold dust. Nearly every

merchant had one or two gold dust scales on their counter with a piece of thick Brussels carpet underneath. A pinch of dust held between the thumb and index finger was priced at twenty-five cents, or "two bits." A gold slug, privately issued in California, was worth fifty dollars.

Debts were paid in gold coin at premiums from 100 to 200 percent. "For instance, we had to pay $300 in paper money for $100 in gold coin," Samuel wrote. "For silver coin, we paid in proportion."

Prominent miners and freighters far from their "home office" readily congregated at the Auerbach store. They trusted Frederick. They relied on him in important matters and transactions. On many occasions, they also left large deposits of gold dust and nuggets for safekeeping, which troubled young Samuel.

WAR, GUNS AND RUNAWAY IMAGINATION

Frederick was in San Francisco paying merchants for goods purchased, the store's safe in Rabbit Creek was filled to capacity and Samuel was sleeping in a back room when two men broke in to burgle. Startled awake, Samuel saw one near the safe and another pointing at him with what looked to be by far "the biggest cannon" he had ever seen.

"I was looking straight down the inside of the barrel and it was blacker and deeper than I had ever imagined any cannon could be," he recalled, adding that the men appeared at least eight feet tall.

"'Open that safe and open it damn quick,' one [of] them yelled. I knew that to do so meant ruin. So I told him I didn't have the combination…that my brother would never trust anyone but himself with the combination. The two of them cursed profusely and eloquently, tied my feet and hands, fastened a bandana handkerchief across my mouth and started drilling on the safe's door."

In what seemed hours to Samuel but may have been a matter of minutes, a group of carousing late owls congregated by the store's gas-lit entrance and started talking loudly with no reason to move on. The would-be safe crackers, agitated by waiting, finally gave up and climbed out a back window.

"I rid myself of the handkerchief, loosened the rope on my hands, untied my feet, and hurried over to a friend whom I rousted from his bed," Samuel recounted. "We then went to see the sheriff."

A full investigation ensued, the two men were never found, the safe was never cracked and Samuel's thoughts, vivid with tales to tell, gravitated

to Civil War rumors: Both the Union League loyalists and the subversive Southern Knights of the Golden Circle existed in Rabbit Creek, with nearly everyone carrying guns and warily watching the other. Could these luckless burglars have been minor "birds of disaster" foreshadowing what was to follow? Sensing trouble brewing, Samuel and a cousin set about safeguarding the store and themselves.

They closed the store's iron doors and pried up several floorboards in the kitchen. Digging a hole in the now dirt floor large enough to hold a boot case, they filled it with the store's records, books, bank notes, checkbooks, cash, fire insurance papers and other important papers. They next nailed the case shut, covered it with oilcloth, filled the rest of the area with dirt and replaced the floorboards.

Samuel bought a Colt revolver and, with his cousin, went out of town to practice target shooting. Samuel fired once and that was enough. Gifting the pistol to his cousin, the two boys returned to the kitchen and again pried up the floorboards, dug out the dirt, retrieved the boot box, put everything back where it belonged, including the boards, and "never told anybody about the matter."

STUBBORN AS A MULE

Structuring business goals to meet the needs of miners and families, the brothers helped promote the town's leisure activities, such as snowshoe races, with purses up to $150. Pony races paid more. The brothers also invested in other business opportunities that seemed prudent. Having lost considerable money on a sawmill operation, they envisioned a real promise in mules.

"As the business in our store had been real brisk we were paying large freighting bills for transporting merchandise in Rabbit Creek and for delivering goods into the neighboring camps after it had been sold," Samuel wrote. "Fred conceived the idea that we could make a good thing out of a mules train to pack our merchandise."

The brothers bought a train of thirty mules and stabled them near the store. They engaged a man from Mexico named José as trainmaster, some packers, several *arrieros* (mule drivers), a cook and Samuel as supervisor. Athletic, smart and physically strong, the mules were loaded with three to four hundred pounds of merchandise each and followed the lead mule that wore a bell around her neck.

"A few mule were ridden by the attendants," Samuel wrote, "and we had favorite ones with names like Rum, Brandy, Whiskey and Port."

From grass and weeds to dried fruits and pasteboard, the mules would eat anything and everything. They understood José; he understood them; and Samuel's efforts were futile. "The mules either could not or would not understand me," he wrote.

Money was saved on freight charges, but that did not offset the time and energy expended on their upkeep. Some mules ran away, some fell off narrow and steep trails, some were injured, some were killed and others just disappeared. "It was as tough and trying a job as I ever tackled," Samuel wrote. "And a tremendous relief to me to be rid of that mule train and out of that business." The remaining mules were sold off at bargain prices.

ON THE OTHER HAND

Lode (hard rock) and placer (hydraulic) operations with miners and prospectors had more appeal to the Auerbachs. "We grubstaked some miners and, when they were broke, gave them credit," Samuel wrote. "Some of our mining investments paid handsomely, but many resulted in losses, so that in the aggregate we did not make any money in those mining enterprises."

During the spring and summer of 1863, the Auerbachs' Rabbit Creek store was quieting down. Frederick heard about silver mines in the surrounding Reese River District and in Austin, Nevada. Telling his brothers they "might be lucky and strike a good chance," he formed a partnership with a countryman named Selig Loewenberg and contacted his creditors for permission to move some goods to Austin, Nevada.

According to a California state law, "If a merchant wanted to move goods or chattels to another state, he had to have the consent of his creditors, else they had the right to attach the property," Samuel explained.

Auerbach showcases and newly purchased goods, "which my brother put in as his part of capital," were packed in wooden boxes on which someone boldly scribbled "Reese River or Die!!" "And the dying part nearly happened."

No sooner than arriving in the Austin, Nevada store, Frederick was overcome with a high fever and dysentery. He slept for days on the dirt floor in a shed behind the store. His weight dropped from 140 pounds to 90. To his good fortune, Frederick had been a member of the IOOF (Independent Order of Odd Fellows) since 1859 and had at one time or another tended

to a sick brother or aided a lodge member. When IOOF members in Austin heard of Frederick's plight, they rushed to help.

A Rabbit Creek miner with a tidy cabin in Austin offered him his place to recuperate. Carefully lifting him off the floor, the IOOF members brought him to the cabin and cared for him until a Dr. Willard, from La Porte, arrived and "pulled him through."

Worried about his brother, Theodore rode a mule for miles from their store in La Porte to find the nearest telegraph office and inquire about his brother's condition. Gratified to know he was doing better, Frederick's recovery was still long. By the time he regained his strength, the business had suffered.

"Fred suggested to his partner to select an assorted stock of goods and hire teams to transport them to Salt Lake City, and see if they could be exchanged for oats, butter, eggs, cheese, dried fruits and other products [to sell] in Austin for cash (which meant gold coin) and in that way pay their joint debts." They were successful, and another shipment of goods sent met with the same result.

The partners dissolved their enterprise, Frederick "assumed all [remaining] debts" and the creditors were "agreeable." Maintaining

Auerbach's on Main Street, 1901. *Herbert Auerbach Collection, Marriott Library, University of Utah.*

Welcoming interiors in Auerbach's on Main Street, 1901. *Herbert Auerbach Collection, Marriott Library, University of Utah.*

the Rabbit Creek and La Porte stores, Samuel, Theodore and Fredrick collected outstanding bills and sold goods for cash "as near as possible."

"We paid all our bills in gold coin when it [was comparable] to currency, which established our credit and our reputation, so that we were given wonderful letters of recommendation to men in the eastern markets," Samuel wrote.

Frederick then set his sights on Salt Lake City. "He was particularly interested in Salt Lake City [referred to as the 'Halfway House of the Pacific'] because of his fortunate trading ventures there and it was reported that the Mormon city was growing rapidly, and the heavy travel of emigrants and gold seekers passing through the Great City of Salt Lake was building up an ever increasing volume of trade," Samuel wrote.

Part IV

"THIS IS THE PLACE"

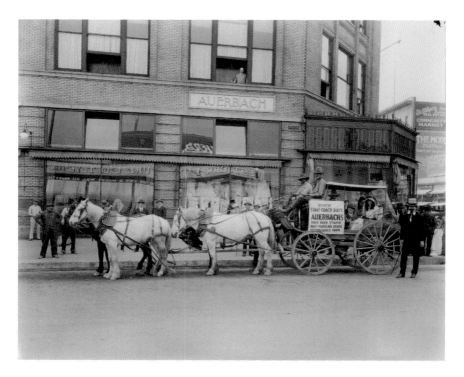

Once used for service (1861–65) into the northern mining towns of Montana and Virginia City, this historic vehicle commemorates the entrance of the Mormon pioneers into Salt Lake Valley, July 24, 1847. *Herbert Auerbach Collection, Marriott Library, University of Utah.*

A WILDERNESS FOR SAFETY

JOSEPH SMITH AND THE MORMON CHURCH

The Church of Jesus Christ, later renamed the Church of Jesus Christ of Latter-day Saints, was founded by the son of a New England farmer, Joseph Smith, and his associates in Fayette, New York, on April 6, 1830.[8]

Living near Palmyra, New York, Joseph Smith reported several times seeing heavenly beings, considered by him to be God the Father and Jesus Christ. At the time of these visions, he was a fourteen-year-old lad. Later, the ardent believer spoke about an angel named Moroni who told of the existence of gold plates on which was inscribed in ancient writing the history of the early people of the Western Hemisphere. Discovering those plates on Cumorah, a knoll by his home, he published the translations in what, for LDS members, became the divinely inspired *Book of Mormon*.

A PLACE SAFE FROM PERSECUTION

By the end of its first year, the Church of Jesus Christ of Latter-day Saints had one thousand devoted members (referred to as Mormons, LDS or Saints). Often faced with discrimination and hostility by suspicious non-Mormon neighbors, they were driven from their religious communities in Ohio, Missouri and Illinois. In 1844, Joseph Smith was shot to death in Nauvoo, Illinois.

Brigham Young, who met Joseph Smith in 1832 soon after his baptism and rarely left his side, considered himself to be an "Apostle of Joseph Smith." He was resolved to undertake the martyr's plan to relocate his people from the East to the Great Basin in the Rocky Mountains, where it was hoped they would be free from persecution.

THIS IS THE PLACE

In 1847, Brigham Young, later elected church president, led an advance party of 148 Mormons into the great Salt Lake Valley. On July 24, while riding in the back of a wagon, ill with Rocky Mountain spotted fever, a tick-borne disease, Brigham Young suddenly sat up and saw the valley below. Reportedly, he said, "This is the right place," which, like ripples in a pond spread throughout the wagon train, resonated as, "This is the place." And it was.

Part V

THE PEOPLE'S STORE: F. AUERBACH & BROS.

Frederick Hillel Auerbach. *Special Collections, Marriott Library, University of Utah.*

Looking Back:
"The Golden Age of Downtown Salt Lake City"

—*Ted Wilson, thirtieth mayor of Salt Lake City, Utah (1976–85)*[9]

As far as Auerbach's, my mom was a "snazzy dresser," according to Bob, my father. She loved the store. I remember getting towed through the crowded aisles by Mom's clutching my hand. She seemed more intent on looking at merchandise than keeping me a prisoner. So I escaped quite often to the drinking fountain; it was a place I thought most wonderful because it ran continuously and it was free! I also remember bells or chimes sounding incessantly in Auerbach's. I guess employees used them to call their attention to customers and product delivery.

It was all a part of Salt Lake's golden years: crowds on Main and State Streets, women dressed to the hilt with hats, nylons, dresses and high heels. Taffy pulled in windows. Hot dog and Coke counters. Clumps of people chatting incessantly along the street, cars parked at an angle and one trip around the block always revealing a parking place. The Utah Theater showed Saturday serials of Buck Rogers, Charlie Chan and the Lone Ranger, with a yo-yo contest at the break. (I won a loop-the-loop competition once and got free tickets for my whole family.) They once ran *Frankenstein* on a Saturday, but the civic leaders complained it was too scary for kids and got the theater in trouble. Ha! We loved it and thought the monster kind of phony. We knew real scare; no monster sings a lullaby hugging a babe in the straw! Humph!

One other great memory: the Auerbach store was super organized like a military detachment in carefully laid out aisles and rows. Much of their merchandise was in glass counters—and there were hats! One day, my mother tried on hats. She loved hats with little wispy nets on them, and the clerk must have opened the hat counter sliding door a hundred times.

Mom usually bought a hat when I was with her. She carefully packaged it for the trip home on the bus and then hid it on the high shelf in my closet. "Don't tell Dad," she said. "I have to first wear it when he's had a drink or two."

Alcohol in dealing with Dad was a shock absorber.

A MOUNTAIN SCHOONER
AND A MAIN STREET WELCOME

I n March 1864, Frederick loaded a mountain schooner with merchandise and drove his mule team into Salt Lake City. Arriving just before dark, he met a congenial Salt Lake resident named Henry Heath, who welcomed him to spend his first night in his family's home.

Henry Heath was eighteen years old when, in 1847, he arrived in Salt Lake with the Edwards Hunter Company's church wagon train, and for several years, he worked as a police officer. Later, he became a longtime bodyguard of President Brigham Young and in 1871 came to work for Auerbach's as a guard and watchman. "A trusted and valuable employee, he was particularly devoted to Fred," said Samuel, "and stayed on until his retirement in December 28, 1889," at age sixty.

Frederick was immediately impressed with the city that foretold a mercantile future unhampered by the booms and busts of transient mining towns. He told Heath he was looking to open a store, and the following morning, Heath escorted him to the Latter-day Saint (LDS) Church office on South Temple Street and introduced him to Brigham Young, the second president of the Church of Jesus Christ of Latter-day Saints.

The next day, the two gentlemen met again for an affable conversation. "Apparently," Samuel wrote, "President Young took a fancy to Fred, and [offered] to find him a suitable location for his store."

Within days, Frederick had moved into an adobe shop that had been temporarily occupied by a carpenter on the west side of Main Street below 100 South Street. He hired the very carpenter who set up his own workshop

in the backyard to build what turned out to be handsome display counters and shelving from Frederick's emptied wooden packing cases.

When Frederick nailed a handmade sign, "The People's Store: F. Auerbach & Bros.," above the door, he ignited another chapter in mapping one of the earliest and finest department stores in the West. He then called for Samuel's help.

BEDBUGS AND POPCORN

Samuel, in Rabbit Creek, often made business calls to Marysville and San Francisco, where he discovered the scourge of popcorn-eating bed bugs for the first time in Sacramento, discovered state fairs and country food and heard stories of "intensely exciting Indian adventures, so fantastic" they could not be true but, related by the legendary mountain man and folk hero "Peg-Leg Smith," were "in truth his very own in the exciting days of the early West." Without delay, Samuel made ready for his next adventure in Salt Lake City.

STAGECOACH, SAND AND JACKRABBITS

Samuel charted his trip by stagecoach that pretty much followed the Pony Express route from California to Austin, Nevada, through Roberts Creek, Sulphur Springs, Jacobs Well and Diamond Springs and into Ruby Valley Station. There, he learned garnets could be easily found in creek beds. Continuing on and stopping at a station every 20 miles for a fresh supply of horses, he and the other passengers "endured nearly 400 miles of a long, dry, dusty, hot ride across the desert."

The endless glistening sand reminded Samuel of the Sahara Desert. It stymied time and turned green oases and water holes into mirages. The hot air fractured, magnified and distorted natural images until sand dunes and funnels appeared as large mushrooms and burned the skin. Whopping jackrabbits, hares with oversized ears for cooling, were "as tall as mules running with the most surprising jumps and amazing gymnastic feats."

Forty miles south of the Great Salt Lake, the travelers stopped at Camp Floyd, where the U.S. Army, influenced by rumors of a Mormon rebellion, billeted some 2,500 soldiers in 1858. Moving on to traverse Cedar Valley, "with its low rolling hills covered with sage and rabbit brush," they glimpsed

the broad and muddy Jordan River that "never seemed so beautiful as it did that day." And as they passed by the shores of Utah Lake, flocks of wild ducks, long-billed snipes and other waterfowl, gulls and migratory birds took flight in a dazzling moiré of feathered flutter.

The stagecoach labored up a steep trail toward the Point of the Mountain, where lawman Orrin Porter Rockwell, the "Destroying Angel of Mormondom" and protector of Brigham Young, operated the Hot Springs Hotel and Brewery in what is now Bluffdale, Utah. From there, the stagecoach continued north and crossed several creeks and "flimsy" bridges until the travelers reached the semi-walled city known as the "City of Saints."

"The trip from California had been arduous and long," Samuel wrote, "but never did I behold a more beautiful and welcome sight than the City of Great Salt Lake."

Waiting at the stagecoach office, Frederick was relieved to see his brother Samuel, and as they walked down Main Street toward their store, Theodore rushed toward them with open arms.

MEASURING TAPE

As he had done in New York City and Rabbit Creek, Samuel walked around this new city. He marveled at the grid pattern, the plat (plot) of ground laid out in symmetrical ten-acre squares (separated by the 132-foot-wide streets, said to be wide enough for a team of four oxen and a covered wagon to turn around) that accommodated public squares, churches, businesses, homes and gardens. The crystal-clear waters stemming from the nearby City Creek Canyon's mountain streams that flowed freely through the city's broad streets and ditches delighted him. Even the city's poplar and pod-bearing shade trees etched "a vivid and agreeable impression on my mind," he said.

Early downtown Salt Lake City lacked paved streets. "At night, the sky was inky black with no lights of any kind," Samuel wrote, "and any attempt to take a walk resulted in a collision with some woodpile stored upon the sidewalk, or [trip] on the boxes and wagons left upon the road by thoughtless residents."

In summer, Main Street was a dusty destination for runaways—those stray horses, cows, pigs, chickens and dogs that "made merry in the street's deep dust," he added. Stirred aloft by cattle drives, thick layers of dust would lift, permeate the air and settle into homes and shops, forcing many to sweep like mad, shut their windows and lock their doors.

The rainy season on Main Street created a seemingly endless morass of mud the consistency of glue. "It was a river of mud; and at times nearly impossible to cross," Samuel wrote. "It was no unusual sight to see arriving stages and freighting teams stuck in the mud; and oxen mired deep."

In front of their stores, shopkeepers set down wooden planks along the dirt sidewalks to prevent passersby from sinking into mud that slogged over their shoe tops—or even higher when the deep ditches that ran on either side of Main Street were filled to flooding with canyon waters. "Mud was king and [with our planks] we started the first round in a battle to free ourselves from its tyranny," Samuel wrote.

BUILDING BUSINESSES AND FINE FRIENDS

The early West heralded an era of enormous space and business growth. The Auerbach brothers operated branch stores; employed emigrating family cousins and nephews; took on business partners when it worked and paid off debts in full when it didn't. They purchased property and invested in real estate and mining.

"Shortly after we located in Salt Lake City, Fred opened a second small store in partnership with [a] Mr. Lavenberg," Samuel wrote. "We sold our business at Rabbit Creek but as the buyer could not pay the entire purchase price we retained an interest in it for a short period of time. At intervals, I made several trips back there to check the books and business, collect outstanding debts and finally settle up the transaction."

In addition to mining for gold, "mining for metals, coal, hydrocarbons and minerals was a vital aspect of Utah's economic, industrial, and social growth and development," historian Philip F. Notarianni wrote in the *Utah History Encyclopedia*.[10]

The Auerbachs were smitten. "While on a fishing trip in Park City, our party slept upon the Ontario ledge which turned out to be the richest bed I ever slept on," Samuel wrote. Originally purchased from prospectors by George Hearst in 1872 for $27,000, by the time of his death in 1891, the Ontario had paid Hearst some $12 million in dividends and was considered to be the "greatest silver mine in the world" in its day. The Auerbachs enthusiastically acquired (and sold) interests in the mine.

LOOKING BACK:
"GOLD CHAINS AND WHITE SANDALS"

—Jill Abrams, Salt Lake City resident[11]

We called it "going uptown to R-backs" in those days. My mother was a very smart dresser. She and I would always go uptown on Saturdays, shop at Auerbach's—that was her favorite store—and have lunch at the restaurant in the basement.

I've always loved jewelry. I remember when I was about twenty years old, Auerbach's had a jewelry counter and case, and a salesperson would open the case and bring out one beautiful piece after another. I bought, and still have, a beautiful, long 14-caret gold chain. It cost about $100, which then was a lot of money. But I loved the chain, the shape of the links and the length. The gold was a pretty gold, too, and I loved wearing it.

I also remember, like it was yesterday, purchasing a little dress at Auerbach's. It was a gorgeous white gossamer linen fabric dress with a subtle flared skirt, elastic waist, sleeves that rolled up with a little tab and button, and on the top, it had buttons that went down the front to the waist and a big, wide and long belt that you wrapped around your waist and tied. The dress was a couple of inches below my knees. It was beautiful, and I wore it everywhere, especially to church, with white sandals and my gold chain.

In the mezzanine, they had a long counter where you could sit and have a slice of cream cheese and date nut bread. I remember, too, a restaurant in the basement, on the left side, where you could get fish and chips, served with those famous hard rolls from the [upscale] Hotel Utah. I don't remember being served tartar sauce, but the beautiful piece of white meat was dry—never greasy—and just melted in your mouth.

My sister, Liz, and I would always have the most delicious chocolate malts and chocolate parfait cookies from a bakery on the right side of the restaurant. They were rather large, light in color with big chocolate square chunks and an unusual flavor that reminded me of almonds. They were so delicious. I've never seen them anywhere else. The bargain basement was there, too, where prices were marked down and more affordable. I found two pairs of earrings that I still have.

These were the days when women wore white gloves and hats when they went shopping, and Mother went quite often. She loved hats. On the third floor, she would sit at a small dressing table with mirrors, and ladies would bring hats for her to try on. They were elegant, fabulous hats that always came in big hatboxes.

During the Christmas season, we'd go often and early. Liz reminded me they would buy powder puffs for Grandma. Women always used loose face powder. These powder puffs were generous, thick and nice, and Grandma would always "ooh" and "aah" over them.

Jill Abrams's beautiful remembrances from Auerbach's. *Eileen Hallet Stone.*

Those were great times: window shopping, visiting my uncle's store, called Giffin's Jewelry, trying on more hats at the [nearby] Paris Co. and always going into Auerbach's uptown.

WORKING MINES AND LIVELY CAMPS

The brothers invested in the Uncle Sam Consolidated Mining Company in Eureka (Frederick personally held mining property in the Tintic Mining District) and the Wilson & Barrett Mining Claim in the Blue Ridge Mining District east of Park City, in which Frederick was president and Samuel was treasurer.

In the fall of 1878, the brothers opened a branch store in Silver Reef, near St. George in Washington County. It made sense at the time. Thirty-seven mines and stamp mills built up the mining district. Nearly two thousand people lived there. A Catholic church offered services within the town, and south of the business district were two cemeteries, including one for Protestants. The mile-long Main Street was lined with dry goods and sundry stores, a Wells Fargo office, permanent buildings, at least six saloons, two dance halls, hotels and boardinghouses, a newspaper called the *Silver Reef Miner* and five restaurants, one of which was called the

Cosmopolitan. There was a horse racetrack, a brewery, a brass band and the Silver Reef Rifle Club.

Property values were high, so much so that miners looking for cheaper accommodations scrambled to set up the tent city of "Rockpile" on a nearby ridge.

Samuel called Silver Reef "a right lively camp." Their store blazed steadily with sales until a fire under the wooden Cosmopolitan spread to the Harrison House Hotel and devoured many other businesses on the street. Rebuilding could not sustain the fear or anger of the 1881 miners' strike, followed by a drop in the silver market. Silver Reef was doomed a ghost town in the making, and the Auerbachs moved on.

During Thanksgiving 1879, the brothers purchased a building on Main Street in Salt Lake between First and Second South Streets. They hired Salt Lake City architect Henry Monheim (later known for his firm's 1894 Richardsonian Romanesque work on the Salt Lake City and County Building) to turn a former furniture store into a new building called the Progressive.[12]

The Progressive building had once been the site of a mail delivery station for the Pony Express and for drivers working for the Overland Stage Company. Years later, on December 14, 1905, Samuel and his wife, Eveline, deeded one-half interest in this property to the Salt Lake Tribune Publishing Company, "the consideration being given as $66,250.00."

WHO WASN'T A STRANGER?

In the vast undiscovered American West, immigrants may have felt like a minority of strangers in a strange place, but the West beckoned people from around the world to participate and set roots in a young region, where opportunities were boundless for brave individuals, no matter how cloistered one group was from another.

The Auerbachs made many acquaintances where business matters and friendships outweighed national origins. They were friends with the prominent Walker brothers. At one time considered among the wealthiest families in Utah, the Walker brothers were bankers and mine owners (including the most profitable and scandalous Emma mine in Alta, Utah). They owned a mercantile, were members of the liberal party and the Godbeite movement and were among the early founders of the *Mormon Tribune*, which later became the *Salt Lake Tribune*.[13]

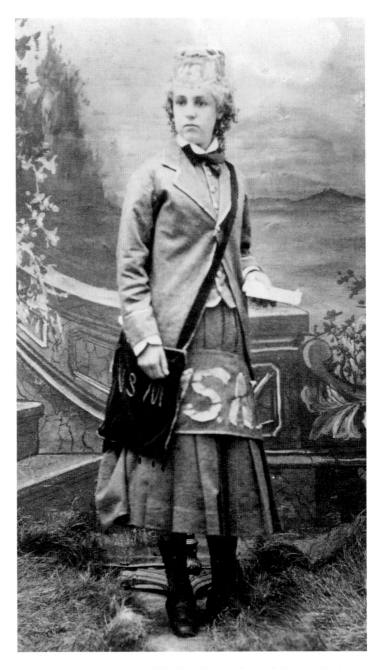

A determined sixteen-year-old Eveline Brooks. *Special Collections, Marriott Library, University of Utah.*

According to Samuel, Rob Walker was one of Frederick's close friends and business associates along with early Jewish pioneer and merchant Colonel Samuel Kahn. In keeping with Walker's sentiment, Kahn was also a financial backer of one of the Intermountain West's earliest philosophical and mildly skeptical magazines, *Peep o'Day*, published by Utah historians and writers Elias L.T. Harrison and Edward W. Tullidge.

German immigrant and mine owner Simon Bamberger, who, after manufacturing clothing in St. Louis arrived in Utah to collect unpaid debts and stayed, also befriended and worked with the Auerbachs. Mr. Bamberger invested in mines and made a fortune in, among others, the Centennial Eureka mine in Utah's Juab Country. He built narrow-gauge railroads to link to coal mines and the interurban Bamberger Railroad that went from Salt Lake City north to Ogden, Utah, and in 1910, he converted it to an electric system. In 1916, Bamberger became the first non-Mormon, Democrat and only Jewish governor of Utah.

As soon as the Auerbachs settled into their new surroundings, they met often (and later conducted business) with Julius and Fannie Brooks. The Brookses, considered the first Jewish family to reach the Salt Lake Valley in 1854, were respected members of Utah's business, religious and social communities. They had a story to tell and an independent, outspoken and stunning daughter named Eveline who eventually caught Samuel's eye.

Part VI

SEVENTY YARDS
OF ENGLISH TWILL

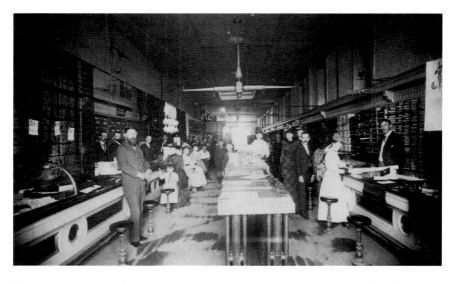

The early beginnings of a marvelous Auerbach store, 1889. *Herbert Auerbach Collection, Marriott Library, University of Utah.*

"FANNIE, LET US TAKE OUR FEW DOLLARS AND GO WEST"[14]

In 1847, twenty-two-year-old Polish-born Julius Brooks packed a carpetbag with clothes; stowed black bread, kosher sausage, crackers and cheese in a box; picked up his rifle, which was a handsome departing gift from his uncle; and, tossing a straw bed and blanket over his shoulder, said goodbye to family members. After five weeks sailing across the ocean, he landed in New York. Paying $1.50 a week for lodging, Julius soon ran out of money. He sold his precious rifle for $100 in gold and opened a small but profitable shop.

Five years later, Julius returned home to visit his family. He told stories about America being the golden medina (a land of opportunity where streets were paved with gold). Seated among his listeners was a young girl just home from college who was interested in what he had to say and willing to return with him. "Yes, if you will marry me, otherwise not," the slight, fine-looking man said. In August 1853, Julius set sail for America with his new bride, sixteen-year-old Fannie, who, unlike her new husband, took to the sea like a sailor.

The young couple roomed at a New York boardinghouse on East Fourteenth Street for $2.50 a week. Fannie, the recent college graduate who played piano and guitar; sang sweetly; and spoke French, German and a sampling of English, enjoyed every moment of New York's busy character and culture. (In later years, more family members would emigrate and resettle in New York.)

When Julius said several months later, "Fannie, let us take our few dollars and go west," she acquiesced, thrilled to discover the western frontier.

FROM STEAMERS TO COVERED WAGONS

In late spring, the adventurous young couple left for Galena, Illinois, where they learned a company was leaving in June for California. Galena was an important commercial center and the starting point where wagons and supplies ordered from Cincinnati and St. Louis were brought to the campgrounds by steamboats. The couple found lodging at a large farmhouse called the Inn and waited to join a train of fifteen Conestoga wagons, also called prairie schooners, heading westward.

According to Eveline, who wrote richly detailed memoirs, her father, Julius, had previously purchased their wagon, which was then brought in by steamer. At a cost of forty dollars, he ordered tents and wagon covers made with over seventy yards of superior twill cotton shipped in from England.

"The wagon bed was twelve feet long, three feet and four inches wide and eighteen inches deep," her parents told her. "Boxes were made to fit snugly inside the wagons to hold utensils and clothing."

In 1854, each wagon cost sixty-five dollars and was supplied with one hundred pounds of flour; fifty pounds each of sugar, rice and smoked, salted, or cured bacon; thirty pounds of beans; twenty pounds each of dried apples and dried peaches; five pounds of tea; one gallon of vinegar; ten bars of soap; twenty-five pounds of salt; and several head of cattle purchased from cattle dealers in the surrounding western settlements.

"It was hoped that the [dry] supplies, milk from their cows, game caught on the plains and fresh water streams would furnish them better food and sustain them through the journey," Eveline explained.

Julius and Fannie bought a little team with two mules. "Although Mother had never driven a horse in her life, she learned within a couple of days how to harness and unharnessed them quicker than any man," her daughter wrote. "The animals became attached to her and after a week, no one could come near them but Mother!"

A limit of ten people was allotted to a wagon and one tent. "One hundred pounds of luggage, including beds and clothing for all people over eight years of age; fifty pounds to those between four and eight years; and no luggage privileges for those four years and younger," Eveline listed. For gold seekers, businessmen, merchants and pioneers, the entire cost to "cross the plains with a wagon train" led by an experienced wagon master and captain was about sixty-five dollars per person.

Wooden Wheels

The overland trek was slow and dangerous. At the beginning, the heat was intense and the dust suffocating. The farther west they pushed, the colder it got. Wagon axles broke, leather straps tore and repairs stymied travel. On some nights, cattle stampedes carried livestock miles from camp. Hard, targeted winds tore at tents and wagon tops. Torrents of rain drenched wagons, obliterated trails and made building fires for cooking nearly impossible. Items not tied down were scattered until buried under wagon wheels. And for many, bedding and clothing were insufficient protections against the cold and rain. Fatigue set in.

"Mother said they did not suffer as many hardships as the previous trains had," Eveline wrote. "They had better provisions, no encounters with hostile Indians, and were always helped by wagon neighbors."

After Fannie turned out loaves of bread that were as hard as rocks and black as coal, her new friends showed her how to bake nice bread on the trail, and she, in turn, taught others how to make German coffee cake, "which she had eaten but never baked before."

Hardships, when they did occur, were irrevocable. "Many pioneers were taken ill, several died along the way," Eveline wrote. "Amongst those who died was my mother's first baby; and before I was born, she was to lose two more children in infancy."

After several months, the wagon train reached Salt Lake City and camped near Haymarket Square on West Temple and First South Streets. The exhausted couple was able to purchase or trade goods for clothing, vegetables, fruit, sugar, tea and coffee. With a yen for the gold fields and a mercantile bent, by spring they had moved farther westward, setting up tent stores along the way. Fannie's oldest son, George, was born in 1857, and in 1859, Eveline was born in Timbuctoo, in California's Yuba District.

They "acquired mining claims and had a gold camp on the Yuba River, near Marysville," Eveline wrote. But by 1860, Julius was tired of the business, Fannie suffered with respiratory issues and the family had moved to San Francisco—and then on to New York by way of Panama.

"Just before we left, I was taken very sick and not expected to live," Eveline wrote. "A large boil appeared on my cheek, which had to be lanced. From that moment, I improved."

Arriving in New York City by the end of June, "Grandparents, uncles and aunts were down at the pier to meet us," Eveline wrote. "I had not yet been named but was called Baby. Fortunately, my mother's younger

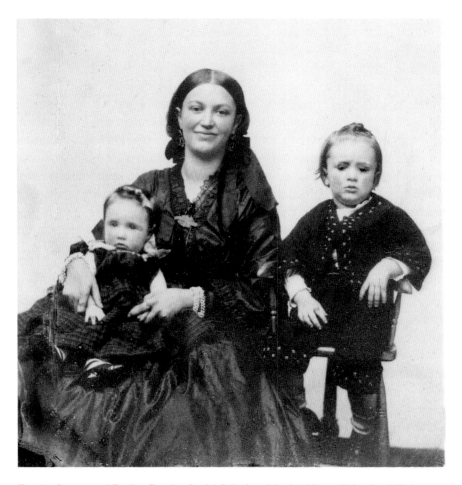

Fannie, George and Eveline Brooks. *Special Collections, Marriott Library, University of Utah.*

sister, Aunt Mary, had been reading a book in which the heroine's name was Eveline."

The Brookses and their now four children eventually returned to Salt Lake City, where the dry climate suited Fannie. In 1867, Julius and Fannie purchased land on the southeast corner opposite the Eighth Ward Square (the site of today's City and County Building) and built seven lath and plaster two-story houses to rent to migrants wintering in Salt Lake before traveling farther westward in the springtime. Each house, composed of two bedrooms upstairs and a kitchen and sitting room below, was "twenty feet front and thirty feet deep, with an artesian well on the one side and the outhouse on the other side" and a porch that ran across the front.

LOOKING BACK:
"JULIUS BROOKS AND HIGH-PRICED NAILS"

—Samuel Auerbach, Julius Brooks's son-in-law

In 1867, Mr. Julius G. Brooks bought a corner facing on the Eighth Ward Square and began to build several frame-and-plaster houses. It was his intention to live in one of these and rent the others. The nails cost him one dollar per pound and putty one dollar per pound. He bought these nails from F. Auerbach & Bros. In later years, after I married his daughter Eveline, he often twittered me about our high-priced nails.

About this time, J.C. Brooks opened the Pioneer Corral located on Third South Street between Second and Third East. He was the proprietor of the Pioneer Corral for several years.

Mr. Brooks told this story on one of his tenants by the name of Acey. Acey had eleven sons, and on a cold winter's evening, when sitting before the log fire, he would say, "John, bring in some wood." John would ask Jim to go. Jim would say, "Dick, you go." Dick would tell Robert to go, and so down the line until at last Dad went for the wood.

A fire occurred at Camp Douglas in 1867, and a great many goods were burned. General Patrick Connor, who [commanded the Utah military district at Fort Douglas] and knew J.G. Brooks as well as Fred and myself very well, spoke to us about this sale. Mr. Brooks and we bought some of these damaged goods and then resold them. Much of the fat J.G. Brooks secured was used in the making of soaps, of which there was then a great scarcity in Salt Lake.

J.G. Brooks arranged with a man named Snell who hired out as an expert soap-maker to direct the soap-making operations, and they turned out vast quantities of soap. The cakes were stacked up in great heaps all over the place, and J.G. Brooks almost pictured himself as a soap king. Snell, however, had put too much lye and not enough fat. As a consequence, when the soap dried, the large bars of soap shrank to almost nothing. They also made a great lot of candles. Although these sputtered profusely, they refused to burn.

For a long time, soap and candle manufacture was a subject of great merriment among the Brooks family and their friends. With Mr. Brooks, however, it was a very sore subject and provoked his ire to such a degree that we no longer thought it was wise to mention it in his presence.

"The whole lot of houses was to cost twenty-five hundred dollars," Eveline wrote, "and Father's friend Acey agreed to build them."

It was slow going, and halfway through the project, Acey's nails ran out. It wasn't until a couple of months later that the freight came in from Omaha and Auerbach's received a shipment of goods that included the ten penny nails; Frederick charged Julius a dollar per pound. "There were fourteen nails to a pound," Eveline remembered. "And the [seven] houses cost one thousand dollars more than they had planned."

Salving sore feelings, in 1870, Frederick loaned Julius money to purchase goods from Fort Douglas, a small military garrison built in 1862 to protect the overland stagecoach mail route and the telegraph lines and later to accommodate California and Nevada Union volunteers led by Colonel Patrick Connor.

"There was tea, coffee, sugar, beans, rice, shoulders of hams and sides of salt pork, saddles, bridles, and leather goods of all sorts," Eveline wrote. "Father bought the entire lot for two hundred fifty dollars. He realized from the leather goods alone eight hundred dollars. The ham and bacon were trimmed and sold to restaurants; and the undesirable parts [were] used to make soap."

The Brookses opened a boardinghouse and remodeled the dining room to seat forty guests for dinner. They opened a furniture store on the southwest corner of Second South and Main Streets and a successful millinery shop and bakery. In 1891, Julius purchased property at 260 South State Street and hired the Salt Lake architectural firm Dallas and Hedges to design and have built the three-story brick and stone Richardsonian Romanesque building called the Brooks Arcade.[15]

Part VII

MATTERS OF CASH, SUPPLY AND DEMAND

JUST ASK FOR IT

Building up repute and stature with staggering amounts of merchandise neatly displayed within inches of one another, Auerbach hung pasteboards throughout the store extolling, "If you don't see what you want, ask for it!"

Shovels and Lace

Products and goods occupied every corner, nook and cranny. Some were arranged in floor displays or on shelving, and others were strategically placed on countertops. Boots and shoes fit for inclement weather, work or cotillions were shown next to racks of stylish ladies' and men's ready-wear, hoop skirts—"fashionable then but difficult to fold for wrapping"—and bustles. Inside and outside the store were displays of farming tools, mining equipment, ropes, wood, saws, shovels, barbed wire, buckets and brooms. There were choices of glassware, crockery, pots, pans, cutlery, coal oil, wallpapers, ticking for mattresses and pillows, unbleached muslin fabrics and patterns for sewing. And did I mention stoves?

Beginning at six-thirty in the morning and winding up long after midnight, the brothers strove to accommodate Utah's growing population by applying the law of supply and demand and bringing in goods from far and wide.

The Auerbachs lived in a small adobe house on Main Street between First and Second South Streets owned by Nicholas Groesbeck. They

occupied a two-story corner store building on the west side of Main Street and later moved to a boardinghouse on the east side of West Temple Street. Samuel's morning routine at the store was handled with efficiency and order.

"In those days, we used coal-oil lighting at a cost of ten dollars gallon," he wrote. "My rule was to clean and fill the hanging lamps in the morning after sweeping out the store, hang out the show—the display of merchandise included sacks of grain, shovels, brushes, and brooms, upon the sidewalk in front of store—add a suit of clothes, find different hats and gauntlet gloves to attract attention, and then go to breakfast."

One morning, Samuel heard an uproar that sent him racing outside the store in time to see a team of oxen settling in on the sidewalk and deftly chewing on brooms "with every evidence of keen relish." It seems the oxen ate only the bristles and rejected the rest.

As curious crowds gathered to watch the draft animals, news spread like wildfire, and more onlookers congregated to view the bovine comedy of brooms and, for some reason, began to shop. That day, business was unusually good, Samuel wrote, having learned that even spontaneous and unusual happenings hold great promotional value.

Auerbach's prices varied when dealing with gold, silver, scrip, the rate of exchange, freight costs, and weight and time, the latter of which could take goods up to six weeks to reach Salt Lake City.

"We bought considerable merchandise at San Francisco; and most of our goods came overland from St. Louis and points farther East," Samuel wrote. "On goods freighted by ox teams from Julesburg, Colorado, we were charged thirty cents per pound; by mule team we paid forty cents per pound."

Shipping products from the East Coast was expensive: a hefty but small stove would sell for $125, while a creamer could fetch $0.40 or $0.50. "Local" green coffee beans sold for $1.25 a pound. A pound of tea—sent by ship to San Pedro, California, and freighted eight hundred miles in by wagon team—cost "$5 currency." Indian Head sheeting bought for $0.60 a yard at H.B. Claflin & Co., a Manhattan-based wholesale dry goods business, sold for $1.25 a yard. Purchasing the finest loose salt, Auerbach's built up a good reputation by pouring the choice mineral into five- and ten-pound bags stamped with "Table Salt put up by F. Auerbach & Bros."

Oats, always in demand, were profitable grains when sold as a food and health product and used as organic packaging material to swaddle eggs and prevent breakage while transporting them in large cases. "There was a time we did a large butter and egg business and had a room in the cellar of our

store for candling with a lit candle and a piece of cardboard with a hole cut in it," Samuel wrote.

Sometimes, when country merchants, customers, teamsters, freighters or out-of-town friends arrived late at Auerbach's, the brothers kept the store open for them to shop as well as allowed them to sleep on the counters or in the aisles. "Blankets would be taken out of stock and they would roll themselves in these blankets and sleep," Samuel remembered. "Most slept in their boots and rarely removed any part of their clothing. The next morning, when they arose, the blankets would be folded and replaced back in stock."

A GIFT OF MORMON SCRIP

From their first meeting, when President Young helped Frederick locate a site for their store, a sound and vigorous friendship began to form. "President Young would frequently visit our store and sit upon the counter discussing theology and the bible with Fred, who was an unusual scholar and student of the Talmud," Samuel wrote. "They could go on for hours."

Shortly after opening, an LDS bishop entered their store, spoke of his parishioners' plight and said many of these good people had taken ill and were sorely in need of medicine. Would the Auerbachs make a small contribution of available medicine to aid in their recovery?

Although the brothers were in "poor financial circumstances," just having opened their new business and committed to paying off all former debts, they were no strangers to sickness. They donated their entire stock of medicinal remedies.

When Brigham Young learning about the contribution, he thanked them. "He was so pleased he told us that we would be permitted to redeem LDS church tithing scrip at face value," Samuel wrote. "As far as I know, we were the only non-Mormon firm to whom this unusual privilege was granted."

Years later, in 1872, Frederick loaned President Young $20,000, which the LDS leader promised and did repay within fourteen days. "He offered to pay interest, but we refused to accept any interest," Samuel wrote. "We did think it rather strange that President Young should borrow money from us, because he was reputed to be very wealthy and to have great sums of cash on hand."

Speaking of Cash

Paper money, greenbacks or any money, for that matter, was rare among the populace, and Auerbach's often sold merchandise by "due-bills" entitling the bearer one, two or ten dollars' worth of assorted merchandise in their store. "We did that to prevent a competitor or individual [having] a chance to come to our store and wanting one staple article for the due-bill," Samuel explained.

Along with accepting "shinplaster bills" printed by Salt Lake City, the brothers relied on charging credit for merchandise, which was "important to do at the time the sale was made, otherwise it was very apt to be forgotten," Samuel noted. "I remember Fred once telling a clerk to make a charge regardless of anything else. In order to impress it on the young man's mind, Fred emphasized, 'Make out a charge, even if the store is burning.'"

And they conducted their mercantile business on the barter system (an exchange of comparable goods and services) or in trade when marketing large quantities of goods and long-distance sales.

They also realized the economic benefits of incorporating a wholesale line in their business. "When we had produce for sale, we'd hang a sign out in the front of the store and teamsters, who wanted 'loading' for towns in Montana, Idaho, Wyoming or Nevada would drop in to see what we had to offer," Samuel explained, listing locally produced foodstuff, such as butter, eggs, oats, dried fruit, salt and cheese.

Risky Business

Freighting goods was risky business. Inclement weather, Indian attacks, white men's robberies, murders, unstable terrain, time delays and unforeseeable accidents from broken axles to roll-overs resulted in human loss and financial ruin for those in the highly speculative business of hauling goods across the plains from St. Louis and points farther east. The same held true when making connections and shipping goods from the Far West.

"During winter, goods were shipped by boat from San Francisco to San Pedro and then freighted eight hundred miles overland by teams to Salt Lake City," Samuel wrote. And once in Salt Lake, a remainder of goods and produce destined for other western states carried its own risks. Samuel admired these strong freighters and teamsters who navigated the often-

unwieldy routes, saying the men were a product of the frontier, dependable, tough as nails and worthy of praise.

"Their trips would start in the early morning hours and often last until long after darkness had descended," he wrote. "They had to drive in heavy rainstorms and raging blizzards, in the blistering heat of summer and the bitter cold of winter across desert and mountain, through sand, mud, and deep snow. It was the work of hardship and privation unending."

BUCKSKINS...IN EXCESS

"We sold and traded in thousands of beaver, mink, marten, fox, cougar, lynx, bear, buffalo robes and otter skins, and deer and elk buckskins packed in bundles or in bales," Samuel wrote, some "green hides" were shipped back to Salt Lake City for further processing.

Cutting up the buckskins, the brothers engaged a number of enterprising Salt Lake women who, developing a cottage industry in the privacy of their homes, sewed the often Indian-tanned skins into gloves, pants and other wearing apparel—all readily sold and constantly reordered.

"The quality and grade of the buckskin and the manner in which it had been prepared—and a sewer's skills, such as those demonstrated by a Mrs. Anderson—were big factors in establishing the price," Samuel wrote. "Some gloves were embroidered on the long cuff and back of the hand with silk floral designs. Others were made with fine beaver skin cuffs and silk embroidery. Those that were beautifully embroidered brought high prices."

Ladies' buckskin gloves were sold from $3.50 to $5.00 a pair, while men's gloves garnered $4.00 to $6.50.

THE DIPLOMAT

Both white and Native American trappers brought in pelts and furs for trade or purchase. In his memoirs, Samuel mentioned Chief Washakie, the diplomat, strategist, warrior and prominent leader of the Shoshone people who traded often with the Auerbach brothers and became fast friends with them.

"Washakie was a real chief, and a sincere friend who was exceptionally interesting," Samuel wrote. "Upon several occasions I met him while doing business at Fort Bridger, which was a favorite camping place for the

Shoshones. Speaking through an interpreter Washakie taught me about the life of Indians and their legends. I was always very glad to see him."

Jim Bridger's site for a trading post in the southwest corner of Wyoming on the Green River near the trade path of the Shoshone Rendezvous was not an accidental location. During a time of extensive fur trading between whites and Native Americans at Fort Bridger, Samuel traded for or purchased massive quantities of hides.[16]

NATIVE BRAIN TANNED HIDES

According to Aaron Kind, manager of the visionary Crow leader Chief Plenty Coups' State Park near Billings, Montana, native brain tanned leather available for trade in the Utah territory would have been produced by numerous indigenous Great Basin and Great Plains tribes, including the Cheyenne, Kiowa, Pawnee, Arapaho, Ute, Paiute, Shoshone, Sioux and Crow.[17] Mr. Kind described the process of brain tanning deerskin as including:

1. Fleshing—scraping the flesh side of the skin over a smooth log or stretching it taut and scraping it within a wooden frame to remove residual fat and meat.

2. Dehairing—soaking the skin in a solution of water and a little wood ash or simply weighing it down with rocks in a fast-moving stream before scraping the hair side of the skin, again with a bone, stone or wooden scraper, sometimes fitted with a metal tip. The dried skin at this stage is called rawhide.

3. Tanning—converting the rawhide to leather by thoroughly rubbing the skin with a paste made from the animal's brain cooked in a small amount of water, allowing the paste to soak into the skin, and then rinsing out the paste. The skin is then squeezed out, stretched and vigorously worked until the hide becomes soft and pliable.

4. Smoking—if waterproofing was desired, the tanned leather could also be smoked inside a bag draped over sticks and hung over a smoldering fire made from green or rotted wood until the leather turned a desirable shade of brown.[18]

Aaron Kind noted that the lighter-colored skins were prized for certain garments, and some of the finer light, supple deerskin used for gloves was the work of eminently skilled tanners.[19]

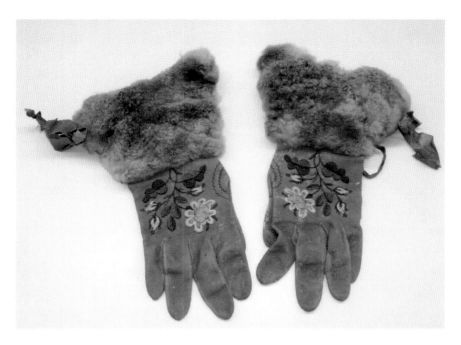

Decorative nineteenth-century ladies' leather dress gloves owned by Hannah Frances Sirrine Mead, Utah Artifact No. 4202. *Photographed by Kari M. Main, curator, Pioneer Memorial Museum.*

TRADE GOODS

According to Kind, articles of trade desirable to Native Americans during this period included: rifles, ammunition, gunpowder, lead, wool blankets, fancy wool shawls, colored calico and red flannel, iron poll-less axes ("trade" or "Squaw" axes), butcher knives, traps, tobacco, notions (such as ribbon and thread), sewing needles, European trade beads, silk handkerchiefs, sugar, costume jewelry and whiskey.[20]

Along with above-mentioned trade articles, Samuel included "brass wire, brass tacks, jack knives, flour and rubber boots with red flannel linings that when turned over showed the red lining"—and kept them all on hand in open stock at Auerbach's.

COMMISSION HOUSES, RAILROADS AND BULLETS

COMMISSION HOUSES

The Auerbachs worked with commission houses (brokerage or merchant firms) in San Francisco that charged fees to manage their accounts and make transactions. "From commission houses we would receive in payment checks drawn on a San Francisco bank and would send same to San Francisco to one [or another] firm to divide the amount in accordance with the indebtedness that needed to be paid to the various parties," Samuel wrote.

Carrying letters of introduction from San Francisco firms, Frederick went on his first buying trip to New York in 1866. He bought goods (half in credit, half in cash) from several fine houses and rented office space with a clothing manufacturing company on White Street. After receiving a bill marked "due" before the store had actually received the goods, he called on the credit manager at A.T. Stewart & Co., a large dry goods and manufacturing firm, to have his credit extended. He was denied.

Asked if Auerbach's shipped goods part of the way by wagon, Frederick replied he did at the end of the line in Omaha, which was called the "Gateway to the West." Then, Frederick, like all other stagecoach passengers, had to tote a sixteen-shot breech-loading lever action Henry rifle or such, which Samuel valued at sixty dollars, before the stage company was given the go-ahead.

As this was not considered a safe way to ensure goods and payment, the manager suggested if the "western merchandiser" waited until the

intercontinental railroad was completed, the company would give him a "reasonable line of credit."

Adding to other transportation problems, goods were usually placed in lightweight cases and iron-band strapped to save on freight costs, but reparation for damaged goods was spotty. "There was a rule in Utah that after the freight was in the owner's possessions, he had not much chance of getting compensated for damaged goods," Samuel wrote, adding, "Some freighters were fair."

When the goods did arrive, the brothers would close the store, open the cases, retrieve the merchandise and check the items for damage before price marking each one. During those times, Frederick and Samuel worked up to thirty-six hours at a time with no sleep "but plenty of coffee and food" brought in from nearby restaurants.

The brothers would then write out a check, and the teamster would receive his pay. "The teamsters took checks from the bank payable in the east," Samuel wrote. "When we had no money, we paid three percent per month interest to the bank. We took such money for as short a time as possible."

"Best quality procurable at the price." Mrs. Ashton's fifty-nine-year-old child's dress. *Special Collections, Marriott Library, University of Utah.*

On another buying trip to New York, Frederick opened the Auerbach's office, lodged at a hotel near Broadway and Canal Street and proceeded to buy out a Canal Street merchant, including his wares, and shipped the entire stock—consisting of derby hats made of fur, men's and women's soft hats, officers' swords, silk sashes and various gloves—westward to their store. "These goods were brought in by mule teams, cost forty cents a pound freight from Leavenworth, Kansas to Salt Lake, and sold like hotcakes," Samuel wrote.

THE TRANSCONTINENTAL RAILROAD

During the six-year (1863–69) construction period, it was a race to build the first transcontinental railroad across America. From Sacramento's railway network, the Central Pacific Railroad Company (CPRR) extended 690 miles of rail eastward. From the railway terminus near Omaha, Nebraska, the Union Pacific laid 1,085 miles of track westward. On May 10, 1869, CPRR president Leland Stanford drove the golden "Last Spike" into the final railway tie with a silver hammer at Promontory Summit.

The 1,192-mile-long railroad line, now open for business, united the nation. Ten days replaced what had been ten months of arduous travel. Transporting passengers and freight became a viable, less expensive and safe option. And, yes, Auerbach's line of credit was extended.

A SPRAY OF BULLETS

The Auerbachs planted stores from Bryan, Wyoming, to Ogden, Utah, and for a time, business was brisk at their site in Promontory across the street from the railroad station. Staffed with cousins Meyer Cohn and Herman Barnett, the young men quickly learned that selling merchandise by day and fending off a barrage of bullets by night went hand in hand.

Trains arriving at the station in the morning or at night would drop off passengers for breakfast or supper including a crew of cappers, who were gamblers' plants. Sitting down at one of several gambling tables set up in town, these cappers would play, bet and show enough winnings to entice naïve passengers to join them and try their luck.

"Before the traveler knew it, he [would] lose," Samuel wrote. Whether the incident involved a sore loser, a capper or a rival gambler, guns often came into play.

During the night, people "would start shooting at one another," Samuel wrote. In the Auerbach store, where they also slept, the cousins would pile boot cases on top of one another, shove their mattresses against the wall and then wait it out, protected against stray bullets.

After a few months, "the boys were used to it and didn't seem to mind," wrote Samuel, who long held an aversion to guns.

THE TRAVELING SALESMAN

No Room—No Inn, for That Matter

Samuel traveled often into Utah's vast surrounding territory, including Idaho, Wyoming and Nevada, to drum up business. For six to eight weeks at a time, he drove a white canvas-top wagon filled with a general line of goods and samples and took "orders for merchandise and contracted farm products."

Curious about life around him, Samuel said he was "always deeply interested in the history of the early West and lost no opportunity to obtain first hand information regarding it." He presented a pleasant demeanor, had a comfortable gift of gab and was eager to converse about the country's indigenous culture and the pioneering experiences of the new settlers.

When he traveled to places such as Brigham City, Ogden or near Camp Floyd, he would take up lodging at a boardinghouse or in a small hotel. Heading into more rural areas where there were no hotels, he was invited to sleep in private homes. "But many settlers were miserably poor, their cottages small with floors consisting of packed dirt and mattresses made of gunny sacks," Samuel wrote. More often, he thanked them for their kind offer and instead retired for the night on country store counters, on tops of billiard tables and in "livery stables," which he believed were "important establishments" that offered both hay for his horses and bedding for him.

"As good teams were essential to rapid transportation, we always took the very best care of our horses and equipment," he wrote, seeing to his horses' needs before taking his own meal.

All the while, Samuel listened to and readily listed for the store what pioneer farmers and settlers said they needed: "Dry goods, notions, millinery, men's clothing, boots and shoes; hats, carpets, linoleums, medicine, and groceries." He noted that while flannel was scratchy, a few pounds of wool "from a sheep's back" were treasured and denim never wore out.

He said when Brigham Young started a woolen mill, it was possible for a settler to exchange a load of wood for cloth and remembered a woodchopper who once told him "he was going up the canyon to the grove to cut himself a suit of clothes."

As always fascinated with food, Samuel ate and rated boiled greens and everything else from "alfalfa to clover, beet tops, dandelions, red root, wild mustard, and rabbit brush to pigs-weed, stinging nettle and summer squash, a horribly popular dish," he wrote. He dug artichoke roots, picked berries and chokecherries, drank coffee "made of burnt wheat and barley" with "savory sucker soup" and occasionally dined on smoked trout, dried meat and lumpy dick, a boiled pudding often made from raw milk, flour, butter, salt and eggs.

And Catching Crickets

When traveling in Nevada, Samuel told of meeting an Indian woman who used bulrushes, partridgeberries and willows to weave exquisite baskets and invited him to a cricket hunt in the fields and a taste of her appetizing-looking loaf of black bread. "She took us over to a good sized stone which had a cup-sized depression in its top and placed therein an assortment of pine nuts, seeds, acorns, roots, berries and dried brown and black crickets," he noted. "Grinding with a smaller stone made this combination into a hearty paste which she said would later dry and bake."

Cricket stews and grasshopper soup "comprised an important part of her tribe's winter provisions," he wrote. It was high in iron and calcium and low in fat. Had Samuel tried the offering, he may have discovered a flavor similar to eating a nutty-tasting shrimp.

In many Mormon villages, Samuel became aware of a spreading financial depression among the hardworking families. Returning to Salt Lake City, he and Frederick would make "special discount prices on certain items to interest the trade" during Mormon conferences and display outside the store rolls of their most popular calico cloth marked down from seventy-five cents to fifty-five cents a yard.

Part VIII

A SLATHERING OF OIL

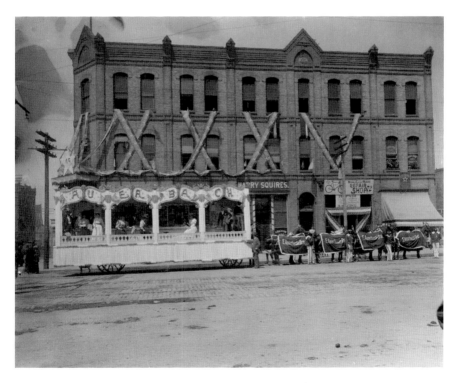

An 1897 Auerbach's outdoor advertisement and celebration of the Mormon settlement. *Utah State Historical Society.*

ILLNESSES, RUBS
AND FRESH AIR CURES

T he illnesses that befell the brothers—Frederick collapsing in Nevada and the childhood ailments that beset Samuel long into adulthood—and the anxiety that followed convinced the men to stock common drugs and medicines alongside the more plentiful home remedies. Such antidotes included the herbal root asafoetida, known as "devil's dung" or "food of the gods," which, when worn in small bags tied around the necks of children, was said to ward off potential epidemics; the standard "whiskey followed by [the laxative called] calomel, whiskey, quinine and more whiskey"; and, for Samuel, a slathering of oil, fresh air, travel and warm clothes.

In the late 1860s, Samuel awoke from a night of terrible pain, "as if I were on fire," he wrote. Diagnosed with consumption, he was advised to rub his chest with the powerfully foul-smelling croton oil, also used as a purgative, and found temporary relief.

Theodore was managing the store and Frederick was in their New York office on 45 White Street when Samuel suffered another bout of illness. One of his Salt Lake doctors advocated an outdoor trip in the fresh air as a cure-all. Samuel immediately made plans to travel by wagon to Atchison, Kansas, and from there catch a "construction" train to New York. There, he'd meet Frederick, who had already set up appointments for him with medical specialists.

Samuel's trip was scheduled for December, and he couldn't escape the feeling of being "cold" all the time. He ordered boots lined with lambskin,

two suits (twenty dollars each) and pure woolen underwear (undershirt and drawers, ten dollars each) from A.T. Stewart Dry Goods in Manhattan; silk socks "and woolen socks" to wear over them; and a "frock coat with long skirts interlined with a twill flannel, heavy overcoat, and other warm articles for the trip."

Greeted by his brother in New York, the two went to Dr. Elonzo Clark's office on East Twenty-Third Street. After examining his patient but asking no questions, Dr. Clark observed obvious lung pain. He suggested that rather than going to Cuba's milder climate, Samuel should take "cod liver oil morning and evening, dress warm, eat good food, rare steak, eggs, and exercise when the weather is good to keep up a good appetite, and come again in fourteen days unless you have pain."

Two weeks later, his "left lung had changed, the other lung was worse," Samuel wrote. He was tired of ingesting cold liver oil twice daily and in no shape to return to Salt Lake. Finding a boardinghouse, "a brownstone on Fourteenth Street between University Place and Fifth Avenue," he paid twenty-one dollars a week for lodging and board.

"The house was owned by Mr. and Mrs. Stein, and it was first class," he wrote. "Shirt manufacturer, Henry V. Rothschild, his wife and two little girls boarded there; also Mr. and Mrs. George Pfeiffer [who were into imports and wholesale notions]." Across the street on the west corner was the elegant Delmonico Restaurant.

On most mornings, Samuel walked from the boardinghouse to work at the brothers' New York office and returned home in time for lunch. In May, he suffered a relapse and revisited the doctor, "a stately and honorable physician who charged only ten dollars a visit."

HORSE LESSONS

Dr. Clark prescribed "a certain bitter liquor" and advised him to take up riding lessons when he went back to Salt Lake City. By the end of May, Samuel felt well enough to travel westward, and once there, he hired a horse from prominent rancher, butcher, railroad man, community leader and friend Charles Popper. All summer long, during evenings except on Saturdays—"when we were busy at the store at night, too"—Samuel rode into the countryside with no cobblestones that long ago in Fordon had frightened him from riding. He had finally learned to ride—and love—horses. His illness was temporarily roped into submission.

Looking Back:
"Fifth Floor, Sporting Goods;
Fourth Floor, Records"

—Arthur C. King, environmental scientist[21]

My mom liked clothes, and we often went to Auerbach's to shop. Decades earlier her mother, who had been in the hat-making business, used to come to Salt Lake to pick up supplies there. That would have been around 1910, and making hats was common for women who worked at home and then sold them to stores like Auerbach's.

After having eight kids spread over twenty years, Grandmother passed away at a fairly young age. My mom, born in 1903, was in the middle. We lived in Carbon County first in Scofield and then twenty miles east of Price in the coal mining community of Dragerton next to Sunnyside, where my dad was principal of the school.

When I was about nineteen years old, I'd sometimes go to Auerbach's with Mother. She would look at the clothes, and I would go and look at other stuff. Auerbach's always had all kinds of stuff.

I remember in sporting goods on the fifth floor, there was everything from fishing rods to baseballs. I took my eyes toward a Browning Nomad semiautomatic pistol for target shooting. Browning is an old Utah company, but this one was a particular Browning made in Belgium. And that model was interesting because it was mainly a target pistol that came with interchangeable barrels. There was a four-inch barrel and a six-inch barrel that by undoing one particular screw on the front of the barrel could be interchanged fairly quickly. So I bought that pistol with the long target barrel and thought it was pretty neat that Auerbach's had enough diversity and did things on the up and up.

See, when I bought my pistol, they told me to hold off for a few days because they'd have to take the pistol over to the police department where the firearm was registered and, I think, even test fired. Then I could pick it up.

I don't shoot animals. I do not. I shoot targets. I just thought target shooting would be fun. Go out to the west desert by

the Great Salt Lake and do some target shooting. That was fun.

"I don't shoot animals. I do not. I shoot targets." *Arthur C. King.*

Over time, I lost interest in it. I started as a freshman at the University of Utah, had some interest in music and started looking at records. Maybe it was on the fourth floor, I'm not sure, but Auerbach's had record displays out at pretty good prices. I must have picked up at least two dozen albums there. I'd write on the back of the album how much I paid for it and the date that I picked it up. A habit from having schoolteachers as parents; you have to record everything. And you start saving everything. Schoolteachers save everything. And I have.

AND TAKE UP FISHING

"In the early days there was little social mixing between the Mormons and the Gentiles," Samuel wrote. "On holidays, we usually went on fishing trips, and picnics in the neighboring canyon. Parley's Canyon, Cottonwood Canyon and East Canyon Creek near Kimball Ranch were the favorite [freestone] fishing streams, plentifully supplied with trout. Frequently, the boys got together and had boxing matches. Boxing was a favorite pastime."

Part IX

FINDING COMMUNITY

Chapter 18

WHERE JEWS WERE
CONSIDERED GENTILES

The Auerbach environment in Fordon was steeped in Jewish culture, knowledge and tradition. Balancing Jewish themes with early western living and business practices for the brothers was challenging. Jews, as well as all other non-Mormons, were considered "Gentiles." Although there was no synagogue or rabbi—or even a Jewish cemetery—many members of the small Jewish community thrived in the mainstream culture and were avid supporters of Jewry.

According to an October 11, 1864 article in the *Salt Lake Telegraph*, religious services were held in the homes of Jewish merchants:

> *The respectable portion of our Israelite citizens commenced the celebration of the Atonement on Sunday and held over till the going down of the same orb. Being without a synagogue, the faithful met in the house of one of our East Temple Street merchants and commemorated the High Priest entering the holy of holies to make atonement for the sins of the people. The conveniences for observance being rather meager, there was little conformity to the Law of Sacrifice. We have respect for the religious sentiments of all men, whatever we may think of interpretations. We should be nothing sorry to learn that some of the Israelites were drawing nearer to Moses. We mean it.*

Later that year, Jewish men and women organized the First Hebrew Benevolent Society of Great Salt Lake City to help Jews who were sickly, poor, "had fallen on hard times" or were in need of a burial ground.

"One of the sections of the constitution adopted by the Society makes it incumbent upon every member to 'observe in due form the most sacred of Holy Days in our calendar, viz, New Year's Day, and the Days of Atonement,'" wrote the society's secretary, Theodore Auerbach.[22]

In 1865, Captain Willard H. Kitteridge (from Fort Douglas) and seven other prominent businessmen, including Frederick, Theodore and Charles Popper, organized the first Odd Fellows Lodge No. 1 in Utah. Located in a room on the back of a two-story building on Main Street and reached by a series of stairs in the alley, its members used "canned fruit and package coffee crates" as substitutes for chairs. Before Salt Lake's first synagogue, Congregation B'nai Israel, was incorporated in 1881, the Odd Fellows Hall was rented for the sum of ten dollars to hold services for the small Jewish community.

Frederick wore the mantle of the state's grand master of the R.W. Grand Lodge of Utah. Yom Kippur services were held there one year, and on the following year, President Brigham Young offered the LDS communal building, called Seventies Hall, in Temple Square to hold High Holiday services.

According to historian Jack Goodman in *Peoples of Utah*, a committee resolution signed by Salt Lake Jewish businessmen Nathan Ellis and the Auerbach and Siegel brothers "formally thanked Brigham Young for his kindness in furnishing this site for High Holy Days worship." In support and respect for the small community, in 1869, Young also donated land for a Jewish communal cemetery.

Frederick was committed to the well-being of Salt Lake's young Jewish community. In 1891, he brought his nephew and architect Phillip Meyer from Germany to design the rock-faced, native Kyune-stone Congregation B'nai Israel building with a soaring Moorish dome and stained-glass windows. Located at 249 South 400 East, the building could seat five hundred congregants of the growing Jewish community. The design was a scaled-down version of the Great Synagogue in Berlin, which was later destroyed by Allied bombers during World War II. Mr. Meyer, who returned to live and work in Germany, died during the Holocaust. The synagogue, retrofitted as the Henricksen Butler Design Group, stands now as an honored and cherished remembrance.

Frederick was also dedicated to all those in his family, bringing other members of the Auerbach family to Utah and setting them up in the Auerbach's branch stores throughout the western region and in downtown Salt Lake City. With his brother Samuel, he supported those still living in Prussia.

THEODORE'S MARRIAGE STRAINS RELATIONSHIPS

A HARD BREAK

While Theodore was finishing up work in La Porte, he met a daughter of Moses Engel, Annie, and married her soon after in 1865. "She was fifteen years old, a spoiled child," Samuel wrote. "I think through the influences of Annie, who was born a Jewess, Theodore joined her in going over to the Unitarian Society." When the couple moved to Salt Lake City, Theodore continued working with his brothers and the firm. He maintained his Jewish identity and affiliations and helped support the small Jewish community. "But Theodore's changing religion angered Fred," Samuel wrote.

Family ties were strained, and Theodore and Annie left Salt Lake City around 1868. Only over the years, when feelings softened, did they talk. "Frederick and I sent them money to educate their sons," Samuel wrote. "They had a lovely girl, too, [who] had a disease in which her blood turned to water. Reaching her twentieth year, the poor child passed away."

Part X

ONCE AGAIN STRANGERS IN A STRANGE LAND

UPHEAVALS AND CONCERNS
FOR LIFE AND LIMB

UNSETTLING TIMES

In the mid-1860s, growing numbers of non-Mormons in the Utah Territory posed a threat to Mormon autonomy.[23] This, in turn, brought retaliation against a perceived invasive population—particularly, non-Mormon merchants and businessmen—they believed was cheating them. To preserve the temporal unity of the Mormon people, LDS Church leaders adopted a resolution pledging its members to be self-sustaining. By 1866, the bitterness between Gentiles and Mormons had reached such heights that the Gentiles, caught in an ideological and economic war, were frightened not only for their future as Salt Lake City merchants but also for their safety and that of their wives and children.

Their concern was exacerbated by two murders. The first occurred on April 2, 1866. S. Newton Brassfield, a non-Mormon from Austin, Nevada, had married Mary Hill, a plural wife of a Mormon elder, A.N. Hill. While on business in Salt Lake City, Brassfield was shot and killed in an alleyway.

Accused of anti-Mormon activities, the second murder, the assassination of Dr. J. King Robinson, a physician at Fort Douglas and superintendent of the First Congregational Church's Sunday school, occurred near midnight on October 22 when he was called out to set a fractured limb for a man who had been in an accident. Although his wife warned him not to go with the caller, the principled doctor was halfway across the street when he was attacked by his caller and four other men toting guns. The good doctor

shouted, "Murder!" His wife ran out of the house, witnessed the assault and the doctor's demise.

Dr. Robinson's death outside his home drew a group of passersby leaving a theater. It also awakened Mr. and Mrs. Brooks, who ran outside to help. According to Eveline, her mother thought she recognized one of the perpetrators running away and was fearful of what would happen next.

"Following this wanton murder, there was intense feeling, great unrest, and uneasiness in Salt Lake, and many Gentiles procured and carried firearms, and rarely walked alone through the streets of Salt Lake," Samuel wrote. "The murderers were never found."

Utah historian Orson F. Whitney described the acrimony and distrust between the two factions:

> *Much bitterness of feeling now manifested between the two classes of the community. Many Gentiles persisted in the belief, which they did not hesitate to express, that it was the purpose of the Mormons to compel them to leave the Territory and that the Brassfield and Robinson murders were events indicating a settled policy in that direction. This, the Mormons indignantly denied, asserting still their innocence as a people of those crimes, and denouncing as a slander the charge that they were bent upon compelling a Gentile exodus. That there was a class of men in the Territory whom the Saints regarded as enemies and did not care how soon they departed, was admitted, but that the feeling against them was due to the fact they were Gentiles, or that it arose from any reason that would have been deemed good and sufficient and have called forth similar sentiments in any State or Territory in the Union, was disclaimed. It is true, however, that so far as that particular class was concerned, the Saints, or their leaders, had hit upon a plan which they hoped would have the effect of weakening if not dissolving what they deemed an organized opposition to the peace and welfare of the community. It was to boycott such of the Gentile merchants and traders as it was believed were conspiring against the best interest of the people.*[24]

On December 20, 1866, such discrimination and potential loss of business moved twenty-three non-Mormon Salt Lake City merchants, including the Auerbachs, to write to President Brigham Young with a compelling request to 1) be paid the "outstanding accounts owed by members of the LDS Church" and 2) their "goods, merchandise, chattels [properties], houses, improvements, etc., be taken at cash valuation," at

which time the merchants would "make a deduction of twenty-five percent from the total amount."

An appeal for more troops was sent to the local government "as to afford them adequate protection." Most likely the merchants' petition was also sent to draw attention to their plight from the federal authorities in Washington.

Had President Young acquiesced, the merchants would have held themselves "ready at any time to enter into negotiations, and once final arrangements being made and terms of sale complied with [they] would freely leave the Territory," Samuel noted.

In a lengthy letter, reprinted in Whitney's *History of Utah*, President Brigham Young explained the position of the Mormon Church in light of the existing situation and added, "It matters not what a man's creed is....He will receive kindness and friendship from us, and we have not the least objection to doing business with him if, in his dealings, he act in accordance with the principles of right and deport himself as a good law abiding citizen should."

He stressed abhorrence of "missionaries of evil [who] have no arts too base, no stratagems too vile for them to use to bring about their nefarious ends" and those "who have done all in their power to encourage violations of law, to retard the administration of justice, to foster vice and vicious institutions, to oppose the unanimously expressed will of the people, to increase disorder, and change our city from a condition of peace and quietude to lawlessness and anarchy.

"Have we not the right to trade at whatever store we please, or does the Constitution of the United States bind us to enter the stores of our deadliest enemies and purchase of them?...It is to these men whom I have described, and to these alone that I am opposed, and I am determined to use my influence to have citizens here stop dealing with them and deal with honorable men."

The twenty-three non-Mormon merchants and their families, representing different religious affiliations and ethnicities and all active law-abiding citizens of Salt Lake City, were baffled. Their businesses were indeed boycotted, and livelihoods and longtime friendships suffered

WAITING IT OUT

I n 1868, the Mormon-run Zion's Cooperative Mercantile Institution (ZCMI) opened its doors and discouraged Mormon patronage of Gentile merchants. Few Gentile merchants dared to walk outside at night. When they did, they took to the middle of the road and carried guns. Some were beaten up; more were harassed.

Charles Popper, the rancher and butcher who in 1867 sold Porterhouse steaks at fifteen cents a pound and mutton quarters for ten, also owned a slaughterhouse, the City Market, and operated one of the earliest soap and candle factories between Omaha and San Francisco. Many neighboring Mormon butchers and others respected him as he respected them. But on October 22, 1869, both Popper and his friend and store owner Ichel Watters felt firsthand the animosity brewing in the town. Witnessing a sham fight in a nearby camp, they were set upon and beaten up, barely escaping with their lives. Later, Watters was beaten up again—this time with brass knuckles.

When LDS Church members claimed to not know the difference between a Mormon or Gentile store, signage soon appeared with the words "Holiness to the Lord" written under an "all-seeing eye" that was fastened above the door of every Mormon shop owner.

"Yet when other ZCMI co-ops with that particular sign were found in many of the smaller towns, as well, for us, this was the 'last straw,' and Fred and I discussed very seriously the matter of moving back to California," Samuel wrote. "Meeting with President Young, Fred said the existing conditions were becoming unbearable and that if they were to continue in

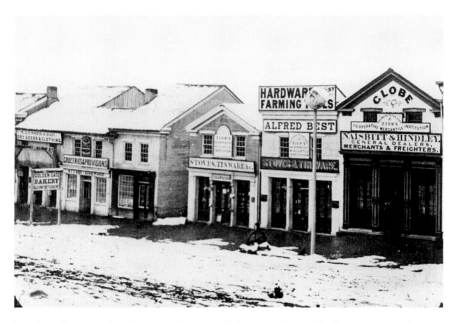

East Temple Street showing stores with ZCMI sign, "Holiness to the Lord" and Zion's Cooperative Mercantile Institution. *Utah State Historical Society.*

this manner, we must soon get out of Salt Lake. The president counseled Fred to be patient, and that everything would come out all right. Following Brigham Young's avowal of friendship, we decided to await developments for a reasonable time. As a last hope, we all pinned our faith to the mines, believing that with the development of Utah's ore deposits, the Gentiles would again have a chance in Utah."

However, the brothers could not avoid what was happening in front of them. "Mormons were ordered not to buy at Gentile stores and the City's police, whose wages we as tax-paying citizens helped pay, patrolled our store at Conference time to warn the Saints from entering."

Spies constantly watched the Gentile stores and reported any known Mormon seen trading there, some of whom were threatened with excommunication. With the sanctions strongly enforced, many of the smaller Gentile merchants were forced to the wall, losing everything they possessed. Conditions were getting desperate even for the larger merchants, who had means and credit.

"Except when there was emigration, our livelihood depended on the trade of Mormons," Eveline wrote. "Upon issuance of this anti-Gentile edict, our houses rented to Mormons were vacated at once."

"GENTILE SIGN."

The above cut represents the Mormon "Co-operative Sign"—called by the Gentiles the "Bulls Eye." At the Mormon conference, in the fall of 1868, all good Mormon merchants, manufacturers and dealers who desired the patronage of the Mormon people, were directed to place this sign upon their buildings in a conspicuous place, that it might indicate to the people that they were sound in the faith.

The Mormon people were also directed and *warned* not to purchase goods or in any manner deal with those who refused or did not have the sign,—the object seemed to be only to deal with their own people, to the exclusion of all others.

The result of these measures on the part of the church was to force many who were Gentiles or Apostate Mormons to sacrifice their goods, and leave the Territory for want of patronage. Some few, however, remained. Among whom was J. K. Trumbo, an auction and commission merchant, who procured the painting of what was known as the

This sign was placed in position on the front of his store, on the morning of the 26th of February, 1869, in a similar position to those of the Mormons. All day wondering crowds of people of all classes, little and big, hovered about the premises, and many opinions were expressed as to the propriety of the sign, and whether it would be allowed to remain by the Mormons; but at about 7 o'clock in the evening the problem was solved, by a charge made by several young Mormons, who, with ladders climbed upon the building and secured ropes upon the sign, while the crowd below tore it down, and dragged it through the streets, dashing it to pieces. This should be a warning to all "Gentiles" in future, not to expend their money in signs to be placed on their stores in Utah—*unless they have permission.*

"Holiness to the Lord," the Zion's Cooperative Mercantile Institution. *Utah State Historical Society.*

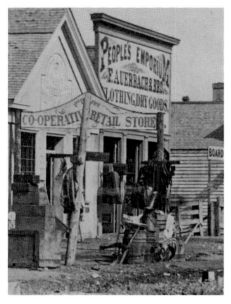

Left: F. Auerbach & Bros., Ogden Store, 1868–69. *Herbert Auerbach Collection, Marriott Library, University of Utah.*

Right: Fannie Brooks. *Special Collections, Marriott Library, University of Utah.*

Fannie Brooks also met with President Young at his office in the Council House and, according to Eveline, said, "Since you have forbidden the Mormons to trade with the Gentiles, our houses are empty. All our money is tied up in property. If we can't rent to them, we will starve." They would have no alternative but to leave. Apparently, the Brookses had been paying tithing to the Mormon Church, which was acknowledged by President Young.

"She was told to have patience and everything would turn out right," Eveline wrote.

The Auerbachs survived in Salt Lake by replacing their signature bags with plain brown paper bags. In shipping goods, they disguised their cases to obliterate their name.

"We had many good friends among the Mormons, as well as among the non-Mormons, and had established a reputation for fair dealing and for selling at lower prices than many other merchants," Samuel wrote. "It became necessary for our Mormon customers to come at night by way of the back entrance in order to make their purchases secretly, for they dared not be seen by the spies of the church. And they carried small purchases in

our plain bags stuffed inside sugar or flour sacks slung over their backs before starting for home."

The Auerbachs never ceased to build up their Salt Lake downtown store with new goods, merchandise and produce. They restocked their branch stores, opened new ones and, joining Gentile merchants and progressive others, looked to Box Elder County and the economic and safe potential of the rail head in Corinne.

"From 1869 to 1870, I was away from Salt Lake a considerable part of time, being often at our stores in Ogden, at our large tent in Promontory, and occasionally at our branch stores in Bryan, which was a notoriously tough railroad camp in Wyoming," Samuel wrote. Much of the time, though, Samuel waited out the Salt Lake City trade wars in the liberal Wild West town of Corinne

Chapter 22

CORINNE

LIVING UP TO ITS REPUTATION

The "end-of-the-trail" town of Corinne was built on the west side of the Bear River along the Union Pacific branch line in southeastern Box Elder County. It was founded in 1869 by a group of former Union army officers and non-Mormon (Gentile) merchants and businessmen who believed that the town could economically and politically compete with the "Saints of Utah."[25]

Called the "Burg on the Bear," the "City of the Ungodly" and "Little Chicago of the West," with its burgeoning population of non-Mormons, Corinne was also tagged as the "Gentile State of Utah" and for nearly a decade was the leading freight-and-transfer junction for the country's vast territory to the north. With nearly five hundred freight wagons coming through town yearly to be outfitted at Corinne, the city radiated, according to Samuel, "lively doings with large quantities of ore and lumber, as well as supplies of every kind handled by these freighters, quite a region for stock raising and the gateway to Montana."

By March 1869, Corinne was home to five hundred wood-frame buildings and sturdy canvas structures and a population that reached one thousand people.

"After the first railway's locomotive hauled its cars across the Bear River Bridge into Corinne on April 7, 1869, this number [rose significantly] with town lots selling for $1,000 each," Bernice Gibbs Anderson wrote in the *Utah Historical Quarterly*.[26]

A wild western town of "blood-and-thunder" repute, there were at least fifteen saloons, two dance halls, sixteen package stores, eighty *nymphs du pave*, several small hotels, a print shop and a daily newspaper that listed the name of train passengers disembarking at the small depot. The Uintah Hotel, a premier establishment, was built with a wooden frame covered with canvas. Its floors were dirt. Its hallway was studded with rooms on either side separated by canvas sheets and outfitted with a wooden bed and a splintery board that served as a rug for sore feet.

A smelter was built on the banks of the Bear River. California redwood was imported to build hulls and beams for steamboats carrying ore and goods across the Great Salt Lake. Colonel Henry House installed one of the state's first water systems. He built a hotel, sawmill and cigar factory. He also operated a ferry service south of the bridge.

Corinne provided entertainment and distraction day and night for constant streams of "floating populations"—those miners, railroad men, gandy dancers, shippers, freighters, tourists and "sporting" crowds from as far away as Elko, Nevada, who poured into town under the watchful eye of a gun-toting marshal.[27]

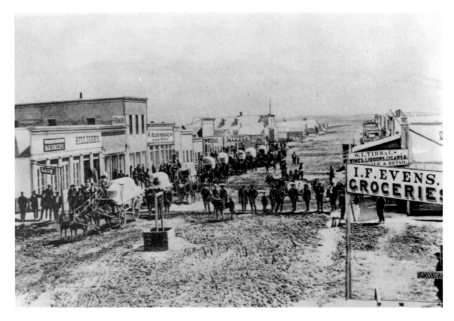

The Wild West liberal town of Corinne. *Special Collections, Marriott Library, University of Utah.*

In 1869, Corinne incorporated as a "third-class city." Its newly formed city council created a "free" school funded by taxpayers. Polygamy within city limits was prohibited. And rules of conduct were established. By 1870, a Methodist church was built.

The newly built Corinne Opera House drew in large crowds to watch national stock company actors put on theatrical performances, séances and musical renditions. According to Bernice Gibbs Anderson, "All the World's a Stage" was painted on the drop curtain along with Shakespeare's face. Scenery was changed by sliding combinations of painted flats planted in grooves onto the stage, and hanging coal oil lamps were lit as floodlights. While there were catcalls, drunkenness and romantic liaisons, only one dogfight ever took place.

Auerbach's wood and canvas store located on the "south side of Main Street, or Montana Street, at the corner of 4th Street," had been busy, profitable and promising—until 1877. Laying rails northward to Idaho, the Union Pacific established Ogden as the junction city, which supplanted Corinne's freighting system and eventually quashed the territory's all-Gentile town.

HARMONY RESTORED

By 1869, development spurred by the transcontinental railroad and mining enterprises precluded all possibility of Mormon seclusion. Shortly afterward, the LDS Church and its leaders ceased to urge its members to boycott Gentile businesses. Although a number of small store owners left the territory broke and uncertain about their future, for many others, peace was restored and friendships were mended.

"Shortly before all this [harmony] took place, some Chinese people of note came from San Francisco on their way to New York, and stayed at my parents' boardinghouse," Eveline wrote. "Every day they would bathe in a tub, as we had no [indoor] bathrooms. And at night they would walk around the house burning punk [Chinese incense]. When my Dad asked why they did that, they said it was to keep the devil away. We never knew whether it was they or Brigham Young who brought us luck. But from then on, things began to improve."

In downtown Salt Lake City, Auerbach's Department Store nary missed a beat, its company logo once again gleaming on paper bags, boxes and packages. After all, this was the West, where business challenges were met

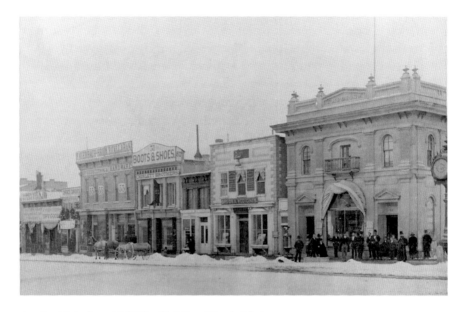

Auerbach's in the mid-1870s. *Utah State Historical Society.*

with true grit, protocol and a modicum of reserve. Opportunities were widespread, the impossible became possible and the brothers' business acumen reached new heights.

Before there were indoor bathrooms, Auerbach's introduced long tin bathtubs, shaped to fit the body, with no plumbing attached to the tub, no running water and no outlet for the used water. "That tub represented such an advance over the washtub set in front of the kitchen stove, it created quite a sensation," Samuel wrote of the promise of future comfort with modern conveniences—plumbed inside the home.

To accommodate the increasing trade, the brothers picked up and repurposed adjacent stores. They constructed, expanded, remodeled, relocated, built up and consistently refined their retail establishment.

Newsprint showered the town with lively Auerbach's advertisements. The original two-inch-square copy that appeared in nearly every issue of the *Daily Telegraph* expanded in size, typeface and black-and-white images as they announced their commitment to stocking "staples and fancy merchandise along with java coffee, choice tea, and fine California blankets offered at a 'little over original cost,'" touting the "newest and most appealing" products they could purchase, import, consign, have made, trade for or have shipped in, eventually silhouetting in downtown Salt Lake City the latest in high fashions from the Pacific and Atlantic coasts to Europe.

LOOKING BACK: "I RAN FULL BLAST"

—Alene McCrimmon, general clothing liquidator and homebuilder[28]

This had to be around 1948, when I was little and we lived way out in Crescent, Utah, what was then called no-man's land. Going all the way to town was a major thing and going to Auerbach's in downtown Salt Lake City the most exciting thing to do, and special. But first, you had to find somebody with a car to take you, because it was a big trip.

We went to Auerbach's on Saturday because on Tuesday morning the newspapers always had a full-page ad on what their Saturday sale was going to be—and they had these big splash things—30 percent off.

So my mother would wait until the newspaper came out, and if there was something that she really wanted, we would plan the trip downtown. It took over thirty minutes to get there. There was no parking, and you had to drive around the block waiting for someone to leave—and then it cost a nickel to park. We usually rode in my grandmother's '47 Chevy.

Once there, we'd stand outside with crowds of people amassed on the sidewalk waiting for them to open the door. Then everyone would rush in, and depending on the sale, it was full combat shopping.

I was a little kid, and for a long time my recollection [was of] running full blast to keep up with my mother, who was striding fast and furious to get to the sale. She would grab my hand and practically drag me around. It was exciting and fun. And when I grew older, it was just such a treat.

An elegant store, there were other stores, of course, but when you walked into Auerbach's, it just lifted you.

I remember their Christmas decorations. They'd close the store on Wednesday before Thanksgiving, cover all the windows and then work. On Friday morning, when they opened the store, they would take down the drapes and there would be all these beautifully decorated windows. And inside, there were fabulous arches and everything in red with ribbons and satin and bows. It was like a wonderland. And for us in the country, going to Auerbach's was an event.

A 1938 Auerbach's Christmas night scene. *Special Collections, Marriott Library, University of Utah.*

They had a tearoom. Mother never took us there—we were so young—but we saw that those who did go in were all dressed up. It was beautiful.

Auerbach's was a big part of the downtown scene. Although there was competition from other fine stores down the street, none were quite up in stature with Auerbach's. When they moved to Broadway and State, where they had a gorgeous corner with two entrances, the way they did the front of the corner was classic and so inviting, I will never forget.

Part XI

COURTSHIP

Eveline Auerbach. *Koopman Family Collection.*

Chapter 23

"I WAS AN ARDENT SUITOR"

n 1876, Samuel made a brief business trip to New York before leaving for Philadelphia to visit the Centennial International Exhibition, the first "Official Fair" held in the United States. He lodged at the Union Square Hotel. Knowing that the Brooks family was living in New York at the time, he invited Eveline for a ride through Central Park in a horse-drawn car and afterward a stop at the ice cream store.

"Sam treated [me] to ice cream and coffee at the Casino and insisted I eat two plates of ice cream, which I had to refuse, as I was never fond of it," Eveline wrote in her memoirs. "He said Salt Lake was where the mines were beginning to pay and, in fact, everybody was looking to a big boom. That year father persuaded mother to go back to Salt Lake and after four years of living in New York we moved back into the house in the garden."

"When I courted your mother, I promised her a nice home," Samuel wrote years later to his children. "I was an ardent suitor."

In early 1878, Samuel took French lessons from a Scottish lady in Salt Lake. He went on a buying trip for the store's spring stock, and after it arrived and was price marked for the store, Samuel left for New York and sailed to Europe on the three-thousand-ton SS *Adriatic* steamer. His itinerary included a go-round of London sites and Parisian shops and a post-wagon ride home to Fordon and the surrounding countryside to visit siblings and their families.

One time, Samuel went into a working-class café "near the [Baroque] l'Église St. Roch on Rue St. Honoré in Paris," ordered a bowl of strawberries

and cream in French and, to his surprise, was brought with it "coffee, bread and butter at a nominal charge." He purchased gifts and "fancy neck wears" at Le Bon Marché, strolled through the Paris Exhibition and engaged a "fair and kind elderly man as a guide at eight francs per day and lunch."

His homecoming was filled with emotions. "I left Berlin for Bromberg and took the post-wagon for Fordon," he wrote. "A distance from town, the driver blew his bugle. I think I gave him five or ten silver *groschen*."

The "folks were glad," he wrote, to see him, and the visits steamed with conversations, food, warmth and sadness. This was Samuel's first homecoming since he departed for America in 1862. He would never see his mother again, as Bertha Friedman Auerbach died in 1866. Now, standing by both parents' graves in the town cemetery, he grieved and held them dear to his heart.

Samuel spent time with Mrs. Mendelson, who lived in the Direction and "cared for me on the first night I was born." He showered gifts upon gifts on his many relatives and talked with nephews about their coming to Utah. And before he left, he gifted each sister's family a thousand marks to purchase a piano and pay for the children's music lessons.

In London, Samuel mapped out an insatiable bounty of destinations. He raced from "the Kew Gardens, Kensington Museum, the Thames Path in Richmond, the King's Stables" and on and on, itemizing costs and capturing scenes in his mind to later relate. It was there he caught up with Simon Bamberger, and Eveline Brooks became a hot topic of conversation.

Mr. Bamberger was working in his London office to raise money to build his Sanpete Valley three-foot, narrow gauge railway to move coal from Manti to Nephi in Utah. He invited Samuel to join him for a "thoroughly enjoyable" Sunday afternoon visit with a railroad colleague on his "15-acre estate in the countryside" outside London. Strolling over the beautifully landscaped grounds and into its natural woodlands was as enjoyable as being waited on by an attentive footman—to whom Samuel left a tip for such excellent service.

On their return to the city, Bamberger queried, "Sam, are you going to marry Miss Brooks?"

It was an eventful weekend. Bamberger did raise $1 million to build his railroad, and Samuel went shopping. Leaving London, he packed inside his steamer trunk a gift-wrapped "large bottle" of Edouard Pinaud's fine perfume and a card-receiver with scenes of the Paris Exhibition for Miss Brooks.

OH GLORIOUS MOON

"Before the Day of Atonement," Samuel wrote, "I received a package containing a pair of embroidered slippers from Miss Eveline Brooks, addressed to Mr. Samuel Auerbach, ready to wear. Where [she] managed to procure a pair of my shoes that enabled the shoemaker to copy and make them fit me I did not find out."

Breaking the fast, he ate dinner at the Brookses' home and invited Eveline out for a walk. The moon was bright; they walked a length of Third South Street and then back home. Samuel bid her goodnight. He returned often over the next few months, and they became engaged.

During a Thanksgiving dinner with Eveline's parents, Mrs. Brooks shared an anonymous letter she received saying her daughter must not marry Samuel, as he was "not able to marry physically." Among other health concerns was consumption. Samuel advised Mrs. Brooks to question his doctor, which she did and, with assurances, was satisfied. "Dr. Fowler [then] advised me to use good old whiskey and milk," he wrote.

WEDDING AMID SNOWSTORMS AND ELEGANCE

After a year's engagement, on Wednesday, December 16, 1879, Samuel married Eveline Brooks in a little cottage on Third South that was beautifully decorated and overflowing with flowers, which Fred ordered from San Francisco. "The little home looked like a flower garden," Samuel wrote.

Choosing a simple wedding with few people in attendance—"to avoid bad feelings of those who were not invited"—the family instead gave money "to buy and distribute coal to the poor of the city."

Frederick had commissioned a tailor named Johanson to make a fine suit of black broadcloth for Samuel. He purchased a "Saratoga trunk and hand satchel for Eveline, a leather trunk for Samuel from Edward Simon & Bros., and a beautiful traveling dress for Eveline made at Arnold Constable & Company in New York." Judge Emerson of Ogden married the couple. In the absence of a synagogue or rabbi, Frederick performed the religious ceremony.

Eveline was fair and slight. She was twenty years old, weighed 108 pounds and had a sixteen-inch waist. A first-rate Salt Lake City dressmaker named Mrs. Swinson made Eveline a white satin dress with a plain waist and square neck trimmed with duchess lace. "The gown had long tight sleeves, fitted

tight at the elbows and closed with four white buttons," Samuel wrote. "The skirt was quite full with four deep flounces."

"And a Watteau pleat from the shoulder falling down the back to which was attached a two-yard-long train," added Eveline. Wearing a veil made of tulle, she carried a bouquet of orange blossoms made of wax flowers.

Two hours before the wedding, which was scheduled for seven o'clock that night, storm clouds threatened a heavy snowfall, and the wedding party worried. Suddenly, as the couple stood in front of family, friends and numbers of Auerbach employees, including salespeople, bookkeepers, "cash boys and porters," the snow sky calmed, and nothing spoiled the ceremony.

The wedding dinner held at the Townsend House on First West and Second South Streets was a feast accompanied by wine, champagne and "cigars in plenty," according to the December 17, 1879 *Salt Lake Tribune*. "Another happy couple was, last evening, sent upon that great metaphorical ocean, called the matrimonial sea, with every indication that makes for happiness and prosperity....His Honor performed his part with the grace of a courtier and made the happy couple one. The Hebrew rites were then administered by Mr. Fred Auerbach, the bridegroom's brother, and the pair were made one in law, religion and purpose."

In its edition, the *Salt Lake Herald* added:

> *A repast was set for those present with the utmost freedom, good nature and general happiness prevailed. The presents were many, costly and beautiful, but particularly noticeable were some floral tributes, which charmed the eye and delighted the senses....*
>
> *Miss Brooks is a lady of culture, accomplished and very attractive—and just such a one as a person would choose for his better half. Mr. Auerbach is the junior partner to the firm of F. Auerbach & Bro., one of our leading dry goods houses, and needs no introduction to the public.*
>
> *Mr. and Mrs. S.H. Auerbach left for the east Wednesday morning, expecting to visit all the principal cities prior to their return. They will be gone until April.* Bon voyage.

The couple spent their first night together at the Townsend House, "that being the only first class hotel in Salt Lake City," Samuel wrote. The following morning, Eveline's brother Edgar and Frederick saw them off on the train.

A HONEYMOON STAY—AND AN EYE TO DETAIL

"We were in Chicago for two weeks and while there, I bought some merchandise and shipped it to Salt Lake City," Samuel wrote. "We stopped at the Palmer House, a new hotel, very popular, and the first big hotel Eveline had ever seen. She was particularly impressed with the immense dining room, its high ceilings beautifully frescoed and decorated, and the large, ornate, crystal chandeliers with their many gaslights. The place was crowded and the myriad of colored waiters hurrying about with their heavily laden trays were very impressive."

Eveline was dressed in a navy blue traveling suit with matching hat, sealskin coat and diamond earrings, "which were quite the rage throughout the Far West," Samuel wrote. "She was exceedingly bashful and as pretty as a picture."

Seeing they were newlyweds, the waiters gave them much attendance and service, which overwhelmed the bride. Samuel remembered, "She was so shy she could not eat with a waiter standing by her chair, and so kept ordering one thing after another as a subterfuge to rid the waiter but he never left her side and simply passed the order to another waiter who went to the kitchen for it."

After dining, "Eveline said she was hungry so we went to a coffee place to get something to eat," Samuel added.

A wedding dress with flounces, flowers that flooded one's senses, ornate crystal chandeliers, frescoed ceilings, a blue traveling suit, leather trunks, diamond earrings, the backdrop of an ornate dining room and a robust good-natured coffee shop—the Auerbachs' choices of textures, colors, shapes, material goods, everyday basics and fine fashion reflected the constantly changing sophistication and simplicity they imbued on every floor of their store.

LOOKING BACK:
"NEW CLOTHES AND A WEDDING STORY"

—Patty Greenwood, former English teacher, Riverton, Utah[29]

My dad was a rancher, raised turkeys in Sanpete County and sold them to the government during the Second World War. My mother, Fay Miner Tanner, always had good taste, and I can remember when she was cooking for the hired men on the ranch, she still wore her heels.

In the early 1950s, Dad was overextended, and we moved to Salt Lake City. That's when my mother started working at Auerbach's downtown. After two years at Brigham Young University, I transferred up to University of Utah. My major was English literature.

ARCILEE, THE BEAUTY OF JANTZEN AND SPOONBILLS

I had one sibling, a sister named Arcilee (pronounced Ark-i-lee), who was twenty-two months older than I was and a year ahead of me in school. Graduating from Provo High School, she was going on to Colorado Women's College, a finishing school in Denver. It was believed it was good for girls to go to a finishing school.

Mother and Arcilee were shopping at Auerbach's for a nice wardrobe to take with her to the college. I remember being there when they were picking out all the clothes. I was jealous. I was bored watching them bringing out all those outfits, but mostly I was jealous. Arcilee chose sweaters and skirts mostly— Janzen sweater sets, Janzen sweaters with white collars. You would fashion the collar around your neck, snap it together and put on your sweater, and your collar would just peek over it.

There were sweater vests with three buttons at the waistline and full skirts with crinoline petticoats. The skinny waist was in, too. I mean, you had to have a twenty-four-inch waistline, and I remember measuring myself every week. I didn't want to be over twenty-four inches. And there was none of this hanging on the hip; all of it was around your waist.

In the early 1950s, stiletto-heeled opera pumps and ballet flats, like the Capezio brand, were all the rage. The Joyce shoes,

called Spoonbills, had a very little heel and a big round toe. They were popular shoes with a kind of faux suede, and you'd have to wear socks that matched your sweaters. Some gals wore straighter skirts, but they were always mid-calf—quite a ways below the knee. There was none of this going without socks. The other shoes were the penny loafers, which you wore with socks.

When I went up to the University of Utah, I wore white bucks, like oxfords but white, and I wore white socks no matter what color the skirt—and shoes were like fifteen dollars a pair.

IN GOOD TASTE

My mother worked at Auerbach's for twenty years. She always had on hose, loved jewelry and helped out a lot of customers. She ran the little millinery on the main floor. In the 1960s, she moved up to Better Dresses on the second floor. There was a dressing room, and I remember the tri-fold mirror with a little rounded platform you stepped on after you got out of the dressing room. You stood on it and looked at yourself from different angles. The dressing rooms were large and the lighting was complimentary—never harsh.

FIRST A BOYFRIEND

I was smitten by athletes and looked for guys in leather jackets, and this guy Dave Bernard Germann, my first husband, was really handsome and athletic. He was destined to be in the air force, taught civics at the high school in Park City where he was also the coach.

He courted me. I'm an Alpha Phi Omega girl, and he was a Phi Delta Theta. The routine was if you were engaged, you wore his fraternity pin, and your pin and his pin were chained together. It was a tradition.

I finished college, and that summer I worked while Dave went away for the summer to play ball in Great Falls, Montana, and then return after the season was finished. I was teaching at Highland High School in Sugar House when he said, "Do you want to get married or I'll never see you again."

Left: Auerbach's catalogue for brides. *Herbert Auerbach Collection, Marriott Library, University of Utah.*

Right: In 2017, Utah journalist Ashton Edwards models Patty Greenwood's sixty-one-year-old and still in style honeymoon dress. *Photographed by Eileen Hallet Stone.*

My parents were not exactly happy [a differing of religious affiliations], but they liked him. So Mother said, "We'll get everything at Auerbach's, at a discount!"

THEY DID IT ALL

Auerbach's printed my wedding invitations, which were off-white and embossed, and an Auerbach photographer took the wedding photographs. My wedding dress was ballerina length with lace, three-quarter-length sleeves and, underneath the slips, lots of crinoline. As soon as I tried on the dress, I loved it. It cost fifty dollars before the discount. And the shoes, oh, they were silvery pumps, the very color that was in my wedding dress. It was a fall wedding and so the bridesmaids wore off-white, strapless dresses with gold stripes.

Auerbach's also delivered a lovely cake: it was a white three-tiered cake decorated around the edges with flowers. And a most beautiful bouquet with fall leaves, gold wheat stalks and yellow roses for me.

We were married during the Utah Education Association [UEA] weekend, on October 12, 1956. I remember we rented the sorority house to hold our reception for forty dollars. And for the wedding, I borrowed my sister's veil. For our honeymoon, my mother had picked out a black sheath topped with a black and white short jacket lined in red silk. My mother had exquisite taste and knew what would look beautiful on you. I still have that dress.

WEDDING BLISS AND SPRING STOCK BILLS

While "honeymooning" in Chicago, Samuel was also at work buying merchandise there. Perhaps as a reaction to his own health vulnerabilities, he felt the need to prove he was as fit and able as his brother. "I had in mind to work very hard, long hours to satisfy my ambition, to show Frederick and the sales people in the house that I could do as well as anybody else and maybe better," he wrote. "I waited on the trade and understood what the different people wanted. I was particular to note on my purchase book, 'Bale all goods that are balable,' and I posted the original bill to Salt Lake and a duplicate to myself."

"Every evening, if we did not go to a theater, I would figure each bill that came in and ensure I did not over-buy, so it would not be said I was going crazy." Samuel kept his brother up to date on the "fine, selected line of goods" he purchased in Chicago, how much they weighed, what they were charged and how they were shipped by rail: "First class, five dollars per 100; flowers and feathers, double first class; plate glass, treble first class."

SOME FUN

Boarding the Baltimore & Ohio Railroad bound for Washington, D.C., the newly married sightseers experienced "more curves than miles," held "on for fear of tumbling out of the berths, and were lucky to reach the end of the journey without broken bones."

Until they built their own home, Samuel and Eveline Auerbach lived at First South Street west of West Temple Street. *Herbert Auerbach Collection, Marriott Library, University of Utah.*

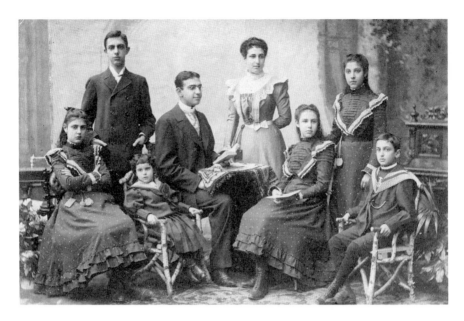

Above: Samuel and Eveline Auerbach's eight children, *left to right*: Jennie, George, Madeline, Herbert, Josephine, Selma, Bessie and Frederick. *Stan Sanders Collection, Marriott Library, University of Utah.*

Left: Madeline and Frederick Auerbach. *Special Collections, Marriott Library, University of Utah.*

The Auerbach clan.
*Koopman Family
Collection.*

From there, they traveled to Baltimore and then New York, where they visited Eveline's relatives, attended a wedding—"Mother wore her wedding dress," Samuel noted—ate oysters, went to the theater and purchased two tickets for good seats for *The Black Crook*, a melodramatic musical comedy (with skimpy costumes). Samuel thought it would be akin to vaudeville. Sitting among an audience of mostly men, "some few women, music and a prize fight," he realized otherwise and whispered to his wife, "Keep your seat, don't let on you're embarrassed; let them think we came for the purpose." They remained until the last act.

Later, returning from the brothers' New York office, Samuel walked by Delmonico's and remembered the first two times he passed by the famous restaurant, checked the prices and kept on walking. This time, prepared to pay the price, he perused the menu, ordered beefsteak with onions, fried potatoes, coffee and cake and was not surprised when he received the bill.

"I could figure it up in my mind, gave the waiter a good tip, and felt my curiosity satisfied," he said.

In April 1880, the couple returned to Salt Lake and, as promised, their very own lovely home.

Samuel and Eveline had eight bright and darling children: Herbert S., Josephine, George S., Bessie, Selma, Jennie, Frederick (his uncle's namesake) and the youngest, Madeline.

LOOKING BACK: "AUERBACH'S SMELLED LIKE PARIS"

—Pam March, owner, Every Blooming Thing,
Salt Lake City[30]

Maybe [it's] because I was an only child and traveled in the company of adults that I remember things from the time I was three or four years old. My mom was a very fashionable and stylish downtown person who worked as a secretary, and so I was often with her. Later, when I was ten, I was able to go downtown on my own. Times were sweeter then, and as I grew up, I became one of those downtown girls.

My aunts JaJuan and Willa Ray were really beautiful. In the late 1940s, Mr. Lillian, the photographer for Auerbach's, did some of the fashion shoots of them for the store's newspaper ads.

Auerbach's was truly a department store, which meant they had many departments. But you could go in and have a nice little lunch on the second floor, and if you looked to your right, you saw all kinds of opportunities to find the most wonderful fashionable hats. And what was so wonderful was if you couldn't afford to buy one then you could still try one on. And even better, in Auerbach's you could always find something that you could afford—or something you could wish for.

It was fanciful, that store. Sometimes it smelled like what you thought Paris would smell like. Every perfume in the world was there. And people would come up to you and they would *flish* your wrist with this or that, and as a young girl, I felt so grown up.

I had a great auntie we adored and took her to Auerbach to find a hat, and she was sitting there, trying on one hat and then

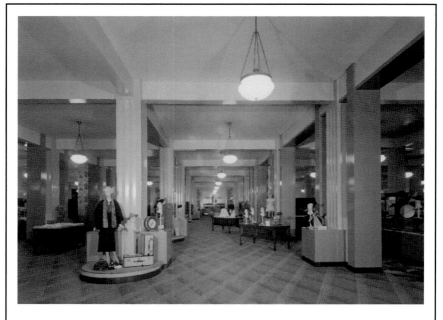

Late 1940s Auerbach interior. *Special Collections, Marriott Library, University of Utah.*

another, and she said, "Look at you, silly; who is that silly old woman who thinks she looks like..." But she was beaming and so pretty with her new hat.

There was ZCMI and Auerbach's and great stores in between where Kresses' had the best pie for a dime, and Auerbach's had those delicious parfait cookies.

But when it came to dresses, they always had quality clothes, from designer dresses in the Crystal Room that you yearned for to the off-the-rack clothing that you could afford that probably mimicked Jacqueline Kennedy's suit or pillbox hat.

I remember my grandmother as a tiny but neat little lady. In those days, there was such a term as genteel poor, and that was my grandmother: genteel, refined, educated and well meaning. When she died, I was twenty-six years old and married. She and I were exactly the same size, and I remember going to Auerbach's to try on the suit that they buried her in.

It was the hub, the hub, of activity. You got on and off the bus on that corner of 300 South and State. In wintertime, before catching the bus to go home, people would walk through Auerbach's rectangular doors into the dazzling decorated

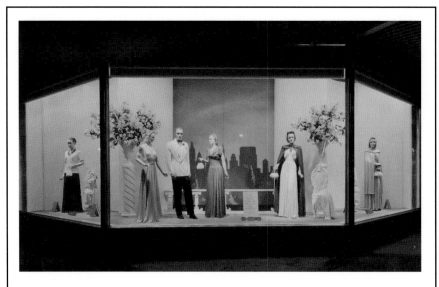

A window display at war's end, 1940s. *Herbert Auerbach Collection, Marriott Library, University of Utah.*

store. Hugging their purchases, they'd huddle inside the steamy little entryway where a couple of radiators kept them warm until the bus showed up to take them home. It was like a ritual, and lovely.

And busy. One of the highlights of downtown was right after the war when everybody had a little money and a little hope. That's when Rosie the Riveter and the other riveting or shell-packing housewives in slacks came out of the factory and into Auerbach's to buy the fashions they had been missing.

Chapter 25

UTAH JOINS THE UNION

O n January 4, 1896, Utah became the forty-fifth state in the Union. In *Beehive History* 21, Dr. Richard D. Poll wrote, "At the counters and in the counting houses of Salt Lake and Ogden some of the earliest overtures toward Mormon-Gentile peace had been made, and by 1896 the Chambers of Commerce and the forty Utah banks had replaced the Schools of the Prophet and Zion's Board of Trade as centers of business planning."[31]

According to Poll, among Utah's citizenry, eight out of ten "were American-born, some nearly nine out of ten were Latter-day Saints" and approximately "two thousand polygamous families remained."

"'Queen of the West' at Last Takes Her Place among the Sisterhood of States," the January 5, 1896 *Salt Lake Herald*'s headline harkened in large, bold print. President Cleveland had signed the proclamation just the day before, and "boundless enthusiasm when the news was heard" led to a "Great Demonstration" as Salt Lake City went wild.

"The news spread as if carried in electrical currents in the atmosphere and soon the whole city was in a wild state of excitement," the *Herald* reported. "Merchants began to decorate their places of business, patriotic citizens hung out the national colors on their private residences and within a remarkably brief period the city was clothed in holiday attire."

Steam whistles tooted, factory whistles shrieked, bells rang and the Utah National Guard fired a twenty-one-gun salute from Capitol Hill.

LOOKING BACK: "THE MISADVENTURES OF SALLY"

—*Sally Shaum, producer/director,*
KUED Public Television, Utah[32]

OK, so I'm seventeen years old and charged with selling luggage at Auerbach's Department Store. It's 1977. I'm working with the son of a manager, I think, eager to hit his daily goal of luggage sales and making sure he doesn't disappoint his father. I remember he wanted me to push the high-quality Hartmann luggage brand. This guy was kind to me but an anxious micromanager trying to do everything just right. He would stand afar and watch my pitch style, then come back and tell me what I did right and what I did wrong. I didn't care for that luggage department. I mean, what did I know about traveling? I didn't have the cash to travel, but I loved working at Auerbach's because the employees were generally interesting, funny and smart.

I was next assigned to the fine china department, where I learned about Mikasa dinnerware in formal bone china or casual stoneware and how to sell it to the mothers of young brides-to-be. I coordinated bridal registries. And I mediated arguments between mom and daughter. I was only seventeen, for God's sake. I was still negotiating with my mother.

One day, I bought two sets of china for my own imagined marriage. That marriage never happened.

The third department was in children's clothing on the fifth floor. I'm not sure how I landed there. I think it was my last chance. The kind buyer for that department told me I must appear engaged in work even during a downtime. So I dusted and re-dusted the metal tops of clothing racks. I adjusted dresses and coats on hangers. I hung up wads of clothes thrown about in dressing rooms. I even called my girlfriends on the department landline until my boss bent her ear and I quickly switched to a customer service tone.

I was a teenager working retail. Two years later, I grew up. I got a desk job.

Two decades later, single and in my thirties, I finally decided to make use of that stored Mikasa stoneware from Auerbach's. There it lay among the silver flatware, among the linen and the crystal and among my personal diaries in my JCPenney cedar hope chest.

"One incident which illustrated the deep feeling of satisfaction experienced by all 'Utonians' transpired at one of the hotels in the afternoon," the *Herald* continued. "A party of old men who have been residents of Utah all their lives sat exchanging reminiscences of days gone by. After a while, the conversation lagged and the group of old settlers sat silent with bowed heads as though buried in the past. 'Statehood,' finally mused one abstractedly, 'well, we have been fightin' for it [nigh] on forty years,' and then they all got up and shook hands as if by common impulses."

Downtown howled with celebrants. Grocers gave out handbills (penny candy and butter, $0.05); ZCMI extolled the newest in Charter Oak Stoves and Ranges; Siegel Clothing Co. offered "underwear at one-third off"; and Auerbach's & Bro. showcased ladies' tailor-made suits at $3.85, children's shoes for $1.00 and "ostrich feather boas from $1.75 to ten dollars."

"January 4, 1896 was," Poll wrote, "more than the birthday of a state. It was the wedding of Utah and the nation."

Part XII

IT'S A HARD BUSINESS, THAT MERCANTILE

FREDERICK STOOD IN THE DOORWAY

L ike most merchants, Frederick and Samuel worked long hours late into the night. Buying trips to either coast ate up days that turned into weeks. If one brother was off on marketing business, the other was at the store. Tying up goods in their wholesale and retail departments took them late into the night, and overseeing the packing, marking and carting of crates of sold merchandise onto trucks "ready to give to the packers" was only the beginning of creating a profitable and smoothly run business.

The two Auerbach offices, one in Salt Lake City and the other in New York, were always prepped for Auerbach's busy and sundry businesses. Keeping up with fashion was full-time work, and personal stateside visits and trips abroad were peppered with store purchases.

Yet, led by an older brother in co-partnership with a younger brother interwoven with familial employment and responsibilities, no one ever said a family-owned business was without its challenges. "I was the substance between the nether millstone and upper millstone," Samuel wrote. "I tried to keep things level and a dammed big job it was."

Admittedly, there were fiery moments between the brothers, but business is business. Brothers are brothers. And eventually, there was forgiveness.

HEARTBREAK

Near the end of June 1896, Samuel was walking outside the store when he bumped into Frederick, who was standing in the doorway.

"He stopped to say he intended to leave on the Fourth of July for the East to buy the fall stock. He wanted to take it easy while buying in the hot weather; it was too hard work to rush around New York," Samuel wrote. "He said I should start to make memoranda for goods required for fall trade, what goods to buy early and ship and what later. I told him I would leave the memoranda ready for him.

"We were on friendly terms. I used to get up at 5:30 or 6 in the morning, go to his room to see if the night watchman had called him to ensure everything was all right at the store, and then I would go with him to the railroad station to see him off. In his absence, we would correspond about business matters."

Earlier, Frederick had told Samuel that Theodore's wife, Annie, had called to ask if "he could extend help." Living with his family in Buffalo, New York, Theodore returned to the cigar business but by receiving cigars on commission and unable to sell them all, he could not afford to pay for them. Frederick wrote a check covering the cost. He told Samuel that Annie was a good woman.

"That was the last important matter he spoke about," Samuel wrote. The day Frederick left for New York "was the last time I saw him alive."

On the morning of September 1, 1896, Samuel received a telegram. Frederick had been taken from the Plaza Hotel where he had been staying and brought to Mount Sinai Hospital for an emergency hernia operation. In a second telegram, Frederick requested Samuel "to come as quick as possible." Samuel dearly wanted to see him; this was his brother, and there was still much for them to say to fix up matters. Rushing to make arrangements to depart by train the following morning, Samuel received a third telegram saying his brother had died.

The news of Frederick's death was stunning and, according to the September 2, 1896 *Salt Lake Tribune*, "came unexpectedly, and fell like a thunderbolt upon his relatives and hundreds of close friends in the city. It was not until nearly dark that the sad news became generally known and immediately thereafter excited groups gathered in front of the Main Street store and at the residence of his brother Samuel on Third South and his sister Rosa on Second South. The intelligence could hardly be accepted, and all were eager to think there was some mistake." Frederick was sixty years old.

On the heels of such sorrowful news, Theodore returned to Salt Lake with his brother's body. After it was placed in their sister Rosa Auerbach Meyer's home for viewing, Frederick's body was taken to Congregation B'nai Israel, where services were held.

"Be just to those departed from this life. My brother Frederick H. Auerbach was a remarkable man," Samuel said in tribute. Years later, in 1920, shortly before his own death at age seventy-two, he wrote:

> *Frederick was always honorable, truthful, his word was his bond, he acted and took the responsibility of a father; he was liberal [and charitable] with what means he had. He sent money home to help our sisters and educate their children and raise them to a higher plane. He said educate them and they will understand how to use the same and elevate themselves.*
>
> *He was a plunger in buying, considering that our territory for selling goods was limited. In early days, New York auctioneers would sell the production of several mills in a day. The sales were advertised in the trade papers and daily papers: "will dispose of 1,000 cases flannels or calico or blankets. Sample cases of the goods can be seen the day before." If he thought prices were reasonable, Fred would buy one or two cases of an item, and sometimes as many as fifty cases. New York merchants would say, "Fred Auerbach understands goods as well as any buyer who comes to this market."*

Welfare of Others

Frederick was concerned about the welfare of others in his adopted city. In his lengthy will, printed in the September 13, 1896 issue of the *Salt Lake Herald*, "the testator remembered a host of his relatives; many charitable institutions are beneficiaries, the employees of the firm F.H. Auerbach & Co. were not forgotten; [and] Mrs. Rosa [Auerbach] Meyer, the largest legatee."

Among forty-seven special bequests, generous sums were made to the St. Mark's, St. Mary's and Deseret Hospitals in Salt Lake and Mount Sinai in New York; the Odd Fellows Library; St. Ann's Orphan Asylum; the Orphans' Home and Day Nursery; the Ladies Hebrew Benevolent Society of Salt Lake; and both the Hebrew poor and the Christian poor "of my native town, Fordon, Prussia."

Frederick reached out to his estranged brother Theodore. "I give and bequeath to my trustees named in my said will the sum of twenty thousand dollars in which for them to invest in the safest manner, the interest of which is to be paid to Theodore H. Auerbach, during his natural life, and upon his death said interest to be paid to his wife, Annie, and if she does not survive him, then upon his death the said sum of twenty thousand dollars to be divided equally between my said brother's children."

A VALUABLE ESTATE

Frederick's estimated estate in 1896 was valued at $407,500. (In 2018 dollars, the Bureau of Labor Statistics consumer price index estimates the value of Frederick Auerbach's 1896 estate as equivalent to over $11.5 million today when adjusted for inflation.)[33] Carefully structured into his will, Frederick defined the means for Samuel to buy out his interest in the store within five years "in a manner as shall not, in the opinion of my executor, work to the injury of my estate nor to the prejudice and hardship of my brother Samuel H. Auerbach, my co-partner in said business."

BREATHE

At the turn of the century (1900 or 1901), grappling with his brother's death, his own health and the onus of fulfilling his legal obligations, Samuel took his family and his mother-in-law, Fanny Brooks, to the spa town of Carlsbad, Bohemia, and its healing hot springs. They then traveled to the Swiss Alps and the city of Lausanne, Switzerland, on Lake Geneva. Although Samuel had to return to New York to buy merchandise for the store, the family rented an apartment, and the children attended school and indulged in outings and fishing trips on the lake. It was hoped that Fanny would stay with them until it was time to return to the States.

Eveline's mother, Fanny, was a successful businesswoman. The dining room in her boardinghouse did serve forty people at one sitting, and her other business endeavors were consistently profitable. In 1885, while she and her husband were vacationing in Remo, Italy, Julius died. His body was returned to Salt Lake City for burial in the city's Jewish cemetery.

After his death, Fanny continued working and helping Eveline and her children until her health began to deteriorate. She often returned to her hometown of Wiesbaden, Germany, to convalesce.

ANOTHER LOSS

This time, the altitude and climate of the Swiss Alps proved stressful for the grandmother of eight. Traveling slowly, the concerned family brought Fanny back to Wiesbaden.

"I was in our office in New York, when a cable came from Europe saying my dear mother-in-law was seriously ill," Samuel wrote. As he made plans to be with his family, a second cable arrived saying she had died. Shocked and saddened by the news, Samuel continued with his plans and arrived by railway in Wiesbaden, where he was greeted by his sons Herbert and George and taken to "Pensione Kordino at Sonnenberger Strasse 10." There he found his "dear wife and children in sorrow and worry" and was told of the sickness and passing away of the loving "Grandma Brooks."

Fanny Brooks's body was transported in a funeral car to the port of Hamburg, shipped to New York and "then by express to Salt Lake where," Samuel wrote, "kind friends and relations showed the last honor and [Fanny's body] was placed in the same vault by the side of her earlier departed husband where they rest in peace."

A FIRE AND A REBUILDING

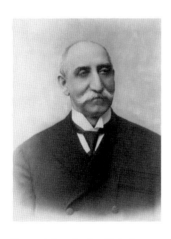

Samuel Auerbach. *Herbert Auerbach Collection, Marriott Library, University of Utah.*

Around the same time, in the spring of 1901, when Samuel was in New York he received a telegram informing him that a fire had broken out at the George M. Scott Building that adjoined the Auerbach Building on South Main Street in Salt Lake City.

Before the firemen were able to close the communicating doors between the two, the fire spread into the Auerbach building and, out of control, destroyed several upper floors. Shaken by the event, Samuel did what an experienced retailer does: he rebuilt. He added another floor to the building. In the coming autumn, by no mean feat, Samuel also accomplished what his brother believed he could do: he resolved the outstanding debts owed and took over the business. Over time, his three sons, George, Frederick and Herbert, would take Auerbach's to the next level.

Part XIII

SPATIAL QUALITIES AND CHANGING FASHION

An (1890–1900) illustration in the *Millinery Trade Review*. *Library of Congress.*

GROWING PAINS

As early as 1890, Auerbach's employees dressed for business. They exuded self-discipline, were informative and knowledgeable about their merchandise and strove for customer satisfaction.

As business prospered, the need for expansion grew. In 1900, the store was located on South Main Street. In 1912, it moved into the former large, upscale 250-room Knutsford Hotel on the northeast corner of 300 South and State Streets. In 1923, it moved almost kitty-corner to the southwest side.

From their tent store days to their department store milieu, the Auerbach brothers demonstrated inherent design skills that reflected their past experiences. They valued space, colors, sounds, scents and taste. They implemented a practical application system derived from knowing the market, understanding people's wants and having the right brands to draw customers into their store. They maintained fully stocked departments from home goods to sports and consistently highlighted the latest of fashion in both sophisticated and ready-to-wear surroundings.

Their floor plans maximized square footage for products while allowing wider aisles to ease traffic flow. For bargain basement shopping incentives, Auerbach's set up sales tableaus stocked with inviting piles of merchandise on tables and creative (wide) "family-style" aisles.

Their interiors aspired to become meticulously staged: departments with curves, columns, softness and personal space were associated with high-end fashion; those with diagonal floor plans invited more casual

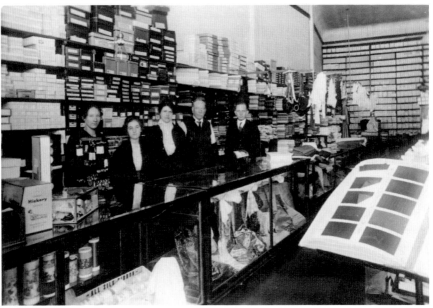

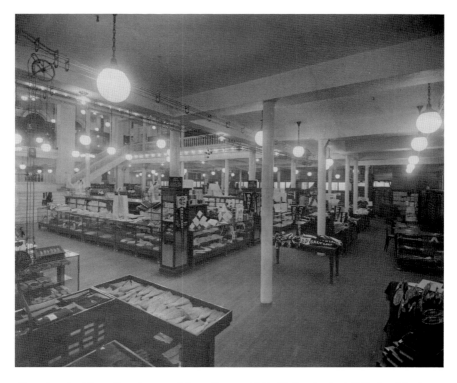

Above: Auerbach's on Broadway and State Streets, 1912. *Herbert Auerbach Collection, Marriott Library, University of Utah.*

Opposite, top: Group photograph of F. Auerbach & Bros. employees, 1890–92. *Herbert Auerbach Collection, Marriott Library, University of Utah.*

Opposite, bottom: Auerbach's employees on Main Street, 1880. *Herbert Auerbach Collection, Marriott Library, University of Utah.*

streams of customer movement within sight of cashiers; and varying floor heights and separating walls cushioned but did not confine departments within departments on the same floor. Lighting quality was always of the essence, as were wall coverings, paint, carpeting, floor tiles and wood. Displays were carefully placed and clearly visible under glass. Clothes were hung in mixed floor plans that included a series of handsome cabinets and shelving for neatly folded items waiting to be taken out and shown. Foliage was used sparingly, and in-store advertising was placed to be seen but not bludgeon customers or physically get in the way of making an actual sale.

LOOKING BACK: "LESSONS"

—Joan Smith, former coordinator for Anytown, USA, SLC[34]

I was a student at the University of Utah and living with my aunt and uncle when I started working at Auerbach's after my last class. I worked in women's sportswear on the second floor. The people who worked there were really darling.

I learned about people, especially men who were anxious and needed something and if they couldn't find it got upset. There was another woman who was right there all the time and helpful in giving me tips so I learned how to remain calm and pleasant. I learned how to use a cash register and all that stuff and to write receipts. I also stocked when the merchandise came in. Everything was just so well lighted, airy and cheerful.

For a young student working there, Auerbach's was a wonderful experience. You learned how to smile, how to be diplomatic and helpful. If you didn't have an answer, you would send them to another department where most likely they would. It was a good way to learn how to deal with people. Maybe that's why I got into the work that I did.

I wore what I needed for school because I had classes afterward. Pants were not in at the time, so I probably wore pretty tailored skirts and sweater sets. Mr. DeConde, who worked there a long time and was maybe in his late thirties, was pleasant and helped me organize my work schedule with my school schedule, which was neat.

I never left working at Auerbach's thinking I was glad to get out of there. I just thought it was a good place to be. And later, when I was no longer working there and out of school, I shopped there.

Chapter 28

GOING UP?

AUERBACH'S SALT LAKE STORE DIRECTORY[35]

DOWNSTAIRS:
The Tea Room, Snack Bar, Bakery and Bargain Basement

STREET FLOOR:
Fine Jewelry, Costume Jewelry, Hosiery, Slipper Bar, Cosmetics, Handbags, Gloves, Scarves, Accessories, Street-Floor Sportswear, Candy Corner, Camera Shop, Men's Shop, Men's Sportswear, Men's Furnishings, Men's Shoes and Town and Campus

SOUTH MEZZANINE:
Housewares, Hardware and Gift Wrap Counter

SECOND FLOOR:
Dress Salon, Town Shop Dresses, Crystal Room and Boutique, Coat Salon, Town Shop Coats, Fur Salon, Sportswear, Women's Foundations, Lingerie, Slimwear and Custom Fashions

THIRD FLOOR:
Salt Laker Shop, Salt Laker Coats, Salt Laker Hats, Daytime Shop, Sorority Shop, Jr. Realities, Young Colony, World of Fashion, Fashion Galleria, Women's Shoes and Maternity

FOURTH FLOOR:
China, Glassware, Gift Shop, Gourmet Center, Notions, Domestics, Draperies, Fabrics, Wall Décor, Stereo and TV, Records and Radios, Record Bar and Books

FIFTH FLOOR:
Children's, Infants', Girls', Boys', Pre-Teens, Miss Teen, Children's Shoes, Toys, Sporting Goods, Trophy Room and Stationery

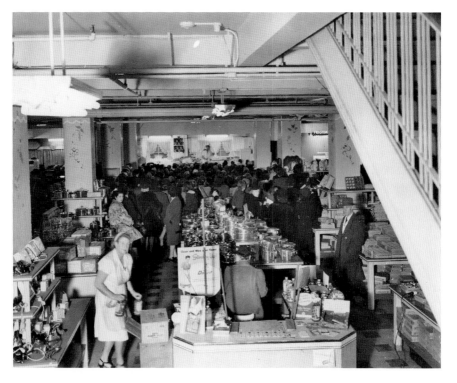

Above: Utah Power & Light Co.'s full kitchen display at Auerbach's, 1947. *Utah State Historical Society.*

Left: Bolts of fabrics, patterns and sewing classes on Auerbach's fourth floor. *Special Collections, Marriott Library, University of Utah.*

LOOKING BACK:
"IT WAS MORE THAN I HAD EVER SEEN BEFORE"

—Daniel G.T., Provo, entrepreneur[36]

It was winter; I was eight years old, and Auerbach's was decorated in almost all white with tons and tons of gold trim. When I say gold, I'm talking color, not metallic, and a white that was not antique looking but a white that shimmered and was more polished than anything I had ever seen before.

In thinking about Santa Claus, there was a big throne that had an aura of green and red surrounded by gold and silver. It was beautiful. They also had a toy department. At Christmastime, you could buy an artificial tree that rained snow. It did; it rained snow. I was older then, and I remember this tree was made of pure plastic that from a distance looked like the real thing. From its cardboard base, a tube ran up the middle of the tree to a skirted angel sitting on the very top. And a little motor would push the snow—little white plastic pieces—up that tube to the angel's skirt, where it would then cascade down the tree into the catch basin in the cardboard box below and be blown back up. My two aunts had to pick it up for us. They thought we were absolutely nuts for paying eighty dollars for it and that my mother was crazy for letting us have it in the first place. But it was a beautifully cascading snow tree, plastic pieces and all.

Broadway and State Streets was the shopping destination, and everything about Auerbach's was upscale and grand. I remember the salespeople as personal, polished, sophisticated and always very nice. The countertops, used mostly for cosmetics, were elegant; and it was the people, the department managers, the assistants and all who made it like that. Everyone looked the part. Why, in the cosmetic department, there was a lady who

Maria Cairo caught everyone's eye. *Alexis Cairo.*

wore chopsticks and sometimes a gold peacock feather in her hair. I don't remember her name, but she was gorgeous, thin, so put together and unflappable.

And I have to say that those great big white parfait cookies with chunks of chocolate—why, I never thought I would taste one again after they closed the store. In the cafeteria in the Clark Building downtown I think they came close to baking those cookies like Auerbach's, but it really was never quite the same. I wish someone had the recipe.

FOURTH FLOOR, DRAPERIES

Memory is personal; one person's perceptions are not always the same as another's, but in reflection, they are rich in detail. When shared, they become tangible prompts to jog other remembrances, and always, as the past concedes to present-day life, they add threads to the tapestry of history. Perhaps this is why Samuel advised his children to take stock of what was happening around them and to write about anything and everything and add to those stunning observations.

The following brief interviews and online comments are a conglomerate of stories recalling Auerbach's remarkable history.

CREATING A STORYBOOK

Alyce Sheba's husband, Dick, was an art major at the University of Utah. "After graduating, he went directly to the job at Auerbach's," Salt Lake resident Alyce said.[37]

"Dick was an artist with a [crew] of several girls who sketched a variety of models and scenes. Then one of the Auerbach photographers, such as Eldon Linschoten, who was very talented and well respected, would do the final shots of the models or the line drawings for the newspaper advertisements."

Dick Sheba eventually became the longtime advertising manager for Auerbach's and also worked for Mr. Samuels, "who owned a department store in Ogden and was in charge of the downtown Auerbach's store," Alyce said. "I remember their office was all the way upstairs. I would go to the mezzanine and sit at the counter. That's where I'd always be to have

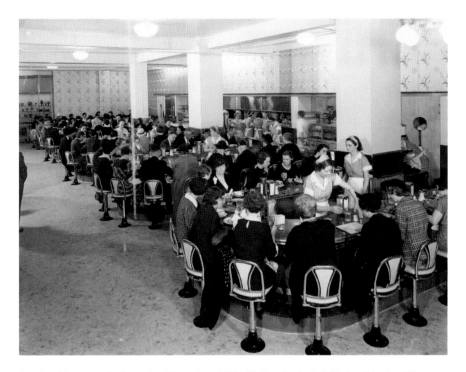

Auerbach's new soda fountain, November 1935. *Herbert Auerbach Collection, Marriott Library, University of Utah.*

coffee and a roll waiting for Dick to have his break. It was a nice time to be together."

Alyce dressed up for downtown shopping. "None of us ever went in 'grubbies,'" she said. "It was social time that got us out of the house, to meet people we know and, yes, to wait for the store's sales. Auerbach's always had good sales on a specific day, and the place would be crowded. Everyone loved it. The day Auerbach's closed, many people were upset and sad."

A SEASONAL WORKER

"It was around 1950 and I was about eighteen years old when I started working in the furrier department on the third floor at Auerbach's," said John Young.[38]

"People brought their furs and they stored them for the summer in a big vault, probably twelve by sixteen feet. They were first fumigated. That would

The fur department at Auerbach's. *Special Collections, Marriott Library, University of Utah.*

kill all the bugs that collected in the furs, and then [they would be] cleaned or restored, if needed."

John Young then ironed them. "I used a rotary iron to straighten out inner linings and along the hemline where there was a little bit of fur. I also helped when the seamstress remodeled some of the coats that had been worn." Taking apart the lining, John would help stretch out the fur and pin it all the way around so a pattern could be chalked, cut and made into a new item, such as a cape.

"They had about six seamstresses working on the coats, and they were always busy," John said. John graduated to working in display, "washing mannequins, helping to dress them and put them in the windows." Then the season was over, and, he said, "by January, I'm out of work."

OH, THOSE DATE NUT AND CREAM CHEESE SANDWICHES

"Auerbach's had a mezzanine counter where you could sit and order sandwiches," said Salt Lake resident Zoe Richardson.[39] "I miss shopping with my mother. We always had a date nut bread and cream cheese sandwich with a cup of coffee. Haven't had one that tasted that good ever since. The most well-dressed clerks worked there and were always pleasant. I had my own charge card, and I remember the elevator lift had chain-linked doors that opened and closed and capable operators—many of them college students—announcing, *Going up? Second floor: Sportswear.* Who could forget?"

ONLINE COMMENTS

From Bruce Allen Kopytek's online Department Store Museum website, we learn:

1) Hannah Pennock, who was originally from England, sampled and then taught Auerbach cooks how to make "authentic English fish 'n' chips" that—light, deliciously textured and never soggy, clingy or sluggish—drew raves from Auerbach's shoppers then and today.

2) The store's handsome cabinets, flawlessly jointed, sophisticated and shimmery, were most likely the result of master craftsman Charles "Chic" Anton Morzelewski. Chic worked at Auerbach's as a carpenter's helper in early 1930. He honed his trade to become a full carpenter and then excelled as foreman carpenter until his retirement after some forty years of service.

3) In an ode to songwriter Ervin T. Rouse's 1939 bluegrass standard "Orange Blossom Special," highlighting a "fiddler's pyrotechnic virtuosity," Ken Despain warmly recalled of Auerbach's golden days:

We lived in Midvale. And sometime in the mid- to late '40s, I would wake up in the mornings to the smell of bacon frying and the sound of the "Orange Blossom Special" blasting from the radio. It was the theme music of Cousin Ray's Record Bar *being broadcast from the mezzanine of the Auerbach's department store in downtown Salt Lake City.*

In 1962, I got a job with Edison Brothers Shoes, Inc. selling ladies' shoes on the third-floor shoe department at Auerbach's. It was hard work for little pay, but it kept me going, and the store was elegant and beautiful.

Despain remembered working at the store and being tossed about during the 1962 Cache Valley earthquake that registered 5.5 on the Richter scale and was felt in Utah, Idaho and Wyoming.

I was walking through a doorway from the stockroom to the selling floor when the doorjamb suddenly hit me in the shoulder and knocked me back and forth in the doorway a couple of times. At first I thought I was dizzy. Then I realized I could hear the whole place rattling, and I heard a scream from the floor above us and dishes breaking. It was all over in a couple of seconds and there was no major damage, but it sure got our attention.

4) One anonymous writer recalled:

My mother and I both worked at Auerbach's in the 1960s. I worked as a janitor picking up garbage cans and doing general maintenance, and my mother worked in the Victory Theater in the basement. That was the first real job I ever had and an experience I will never forget. Auerbach's had a package chute, called "a cork screw slide," that went from the fifth floor all the way down to the delivery room in the basement. If someone put too big a package down the chute and it got stuck, it would back up packages all the way up to the fifth floor, and we'd get a call to ride the chute to the blockage to dislodge the packages. Most of the time, we would get it unblocked and ride the slide all the way to the basement. We were told to get out after undoing the jam, but most of the time we were moving too fast to stop. There was a conveyor belt that took the packages to another slide, which would drop them into the delivery room. I think about that store every once in a while and smile. It was a great place to work.

Chapter 29

THE MEAT MARKET AT AUERBACH'S

Born in 1919 in Salt Lake City, Harry J. Doctorman was in the family's meat and cattle business. He was also a champion veal skinner.[40]
"A good butcher was a guy who knew how to skin and saw and drop the guts out of the cattle without cutting them. I could skin a veal in seven minutes," he said. "I could cut meats very well, too, and break the meat up into pieces. But I never killed cattle. You couldn't get a kid to go out and work on the killing floor. No, I never worked on beef or on the killing floor."

In the early days, Doctorman said there were around fifty or sixty butcher shops in Salt Lake City "but no chain stores. And very few stores that sold both groceries and meat. It was usually one or the other."

Perishables were kept in iceboxes—often the kind of well-insulated wooden or porcelain cabinetry with nickel-plated hardware—designed as side or overhead icers. Blocks of ice were purchased from and brought in by ice harvesters. Mechanical refrigeration didn't go into mass production until the 1920s.[41] "Even then, a lot of the butchers might not have had refrigeration at the time. The iceman used to deliver fifty to a hundred pounds of ice and store it under the counter, and the butcher would rest the meat on top of it to keep it cold," Doctorman explained.

Auerbach's was one of the cattleman's customers. "They were on Third South and had a big meat market down in their department store. They even had an elevator," he said. "We'd bring the meat downtown and have to carry it about a block until we got to the back of the building and the

LOOKING BACK: "ON THURSDAYS, THERE WAS MEATLOAF"

—Gail Bernstein Ciacci, Salt Lake City native[42]

When we were young, we used to follow our mothers to Auerbach's, and we enjoyed it because everywhere you looked was so interesting, even at that age. Everybody was nice, too. Nobody minded that the children were there with their mothers. And I could never get lost because I knew where the exits were and the elevators all had operators who would help if anyone did [get disoriented]. Of course, we weren't allowed to run around or we wouldn't be invited to come back the next time!

Occasionally, Mother would treat us to lunch at the Tea Room in the basement. The Tea Room had a set menu. If you went on Thursdays, you'd get meatloaf. On Fridays, it was turkey. Going there with Mother was a special treat. I remember white tablecloths and napkins and really lovely chairs to sit on. The food was good and economical; the fish 'n' chips were light tasting and delicious.

For years, I shopped at Auerbach's, sometimes with my mother, sometimes with friends and even on my own. I just loved the street level because there was everything there from gloves, handbags, scarves and jewelry to sportswear for men, like my dad. You could get anything wrapped for free in the mezzanine, and the packages all looked like presents. They made a very beautiful presentation.

In those days, everyone got dressed up with hats, gloves and handbags to go shopping downtown. They always wore high heels. Upstairs was where all the sophisticated, high fashion was in a beautiful surrounding. Just going there was a step up, like you were being treated to New York or even Paris fashion.

Most of all, what I liked was that the people who worked there and would help you were skilled salespeople. They would leave you alone while you were looking and be right there if you had a question. You never felt hemmed in. They never pressured you to buy or made you feel you had to hurry to make your choice.

I will never forget the woman behind the cosmetic bar. She must have been there for years and was still the best. I was young, but I remember her always looking beautiful. She taught women how to wear makeup that would be flawless—and isn't that what we all want? My girlfriends and I didn't start wearing lipstick until we were in our teens, and in the meantime, I always watched as my mother chose her makeup.

elevator. I'd then have to take the meat down the elevator and haul it over to the other side of the building where the meat market was."

During World War II, he and his father, Joe, sold 80 percent of their stock to the government and were granted a government inspection certification, which eventually expanded their sales to the East and West Coasts.

FASHION PLATE 101

Uncle Joe's Bermuda Shorts

"One has to wonder *why* about fashion," Brenda Van der Wiel said.[43] "Why were bustle dresses—those straw-filled cushions and steel structures sewn into skirts or attached to the waist—so popular in the late 1800s, and why did twentieth-century women covet the return of the 1830s hourglass shape, the narrow skirts and raised waistlines, or the broad-brimmed hats trimmed with hummingbirds that soon evolved into 'drooping' brims that covered the face?

"For that matter," the assistant professor and head of the Performing Arts Design Program at the University of Utah questioned, "why *did* Uncle Joe wear Bermuda shorts and knee socks to work in the 1950s? And even more personal, why did *I* ever think I should leave the house wearing…what?"

Brenda Van der Wiel said many factors affect clothing choices, and "the role of women in any given society can be guessed at by a cursory look at the history of women's undergarments," from stays, panniers and corsets to crinolines, bustles, brassieres, chemises and kimonas (the latter named for women's casual attire worn by women in the Philippines and Vasayas Islands).

Auerbach's 1907 mail-order catalogue, called the *Economical Shopping Guide*, expressed the captivating idea of daintiness as occurring "in the very place a critical woman most demands it." Most importantly, the catalogue guaranteed, "the store performs what it promises."

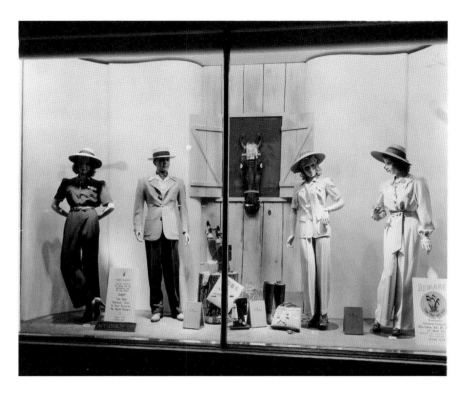

Above: Late 1940s "Derby Fashion" with "No Mend Hosiery" in the second-floor Campus Shop. *Herbert Auerbach Collection, Marriott Library, University of Utah.*

Left: Auerbach's *Economical Shopping Guide*, 1907. *Herbert Auerbach Collection, Marriott Library, University of Utah.*

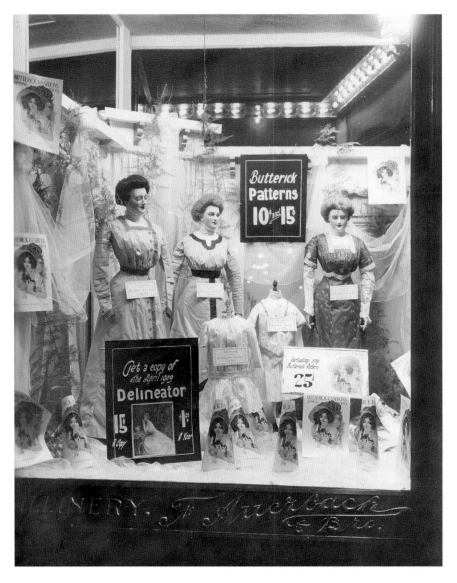

Window display at Auerbach's, 1909. *Utah State Historical Society.*

Item No. 305, a long kimona of "silk finished crepe, in fancy Persian and floral designs, shirred yoke, border and sleeves, trimmed with satin, sizes 32 to 44," was priced at two dollars.

Feminine Morality

"Travel by wagon, boat, ship, automobile and eventually plane brought its own fashion changes responding to those specific modes of transportation," Van der Wiel added. Let's not forget bicycles. In the 1890s, the golden age of cycling in America was in full bloom. Men wore full cycling attire without provocation from the public and inaugurated a shopkeeper's bustling new line of sports clothes.

Dress reform for women sparked rabid debates on feminine morality, unhygienic saddles and sexual arousal. But when the restrictive clothing of the 1890s—the whalebone corsets, voluminous petticoats, cumbersome dresses, tight waistbands and collars and long sleeves—gave way to practicality, they boosted sales on pedal pushers, née bloomers.[44]

Every Which Way, Loosening Ties

"Every year brought its own fashion tweaks, but in general, waistlines dropped and hemlines rose," Van der Wiel noted. "The form-fitting looks of the early 1900s gave way to a silhouette that ignored the trim waist and sought to minimize the bust and hips, lending a more boyish shape. Desiring freedom from Victorian mores and demanding a higher level of fulfillment and adventure, highly restrictive corsets, heavy petticoats and tight form-fitting clothes were abandoned."

Into Society

Paris has long been considered the capital of fashion, and French monarchs were famously renowned for their luxurious tastes in clothing. Louis XIV (king of France, 1643–1715), known as the "Sun King" for his extravagances, ignited a one-upmanship in design involving wigs and curled hair—lots of it.

"Louis XIV sought to make Paris the most influential leader in luxury clothing and textiles," Van der Wiel said. "And when nearly one-third of paid jobs in Paris were in the clothing and textile industry, Paris became the unchallenged leader of fashion for many centuries.

"Some critics may argue it still remains so," she acquiesced, "but during the 1900s, American designers began to fight for some of the spotlight."

The deprivations caused by World War I and the subsequent trade restrictions between France and the United States forced American clients of Parisian couture to find other providers.

"Hollywood movies were becoming influential, American women were enjoying their earned right to vote and other benefits of female emancipation battles and jazz music was spreading across the country," Van der Wiel said. "The 1920s fashion blossomed in this new sense of freedom—in particular, the freedom women felt to express their femininity."

The new tubular dresses for the un-corseted figure (a Parisian design), the bobbed hairstyle once reported as "an incentive to crime" and the close-fitting, helmet-shaped cloche that "skimmed the nape of the neck" pushed fashion forward until the Wall Street crash and the Great Depression brought it all cascading back to conservatism.

RETURNING TO NORMAL

Like a pendulum, that swing back was responsible for the evolution of fashion during the 1930s. The bust was emphasized rather than flattened, the waist returned to a normal position and the more tailored silhouette of skirts and blouses, shirtwaist dresses and suits signified the practical norm.

"In high fashion, however, the glamour of Hollywood remained the name of the game. Actresses wearing the newest styles were featured in fashion magazines. Films were filled with glamorous clothes, and movie studios would market their costume designers almost as vigorously as their leading ladies. The opulence and extreme femininity in fashion provided by the entertainment sector helped foster a sense of calm and hope for the many suffering with financial hardships," said Van der Wiel.

THE WPB

During the 1940s, World War II, wartime shortages, rationing, unavailability of certain fabrics, bans on imported material and "limits on the number of garments consumers could buy placed restrictions on designers and a store's merchandise variety and sales," said Van der Wiel. "Men went to serve their country, women entered the workforce in larger numbers and practical work-wear included military-style and masculine tailored clothing."

The U.S. War Production Board (WPB) reserved specific fabrics and materials, including nylon, silk, rubber, leather and wool, for combat or combat support purposes exclusively. The WPB's Limitation Order L-85 then imposed restrictions on the design and manufacture of feminine apparel. The manufacture of "frills," such as French cuffs, double yokes, mutton sleeves, pleating, shirring, tucking, epaulets, reversible skirts, more than two buttons on a cuff or use of any virgin or reprocessed wool was punishable with stiff fines and even jail time.

Following the war, "the fashion designers who had found ways to create within wartime rations and masculine sensibilities were thrilled to leave behind the utilitarian clothing of the war years and use volumes of fabric in truly feminine silhouettes," Van der Wiel explained. "Full skirts, closely cinched waists, round full busts and soft shoulders were the coveted style of the 1950s. Petticoats and corsets saw a reemergence, although these undergarments, made with softer and shinier synthetic materials, were much more glamorous and comfortable than their Victorian predecessors."

Auerbach's second-floor Ready-to-Wear. *Special Collections, Marriott Library, University of Utah.*

Fashion in the 1940s. *Special Collections, Marriott Library, University of Utah.*

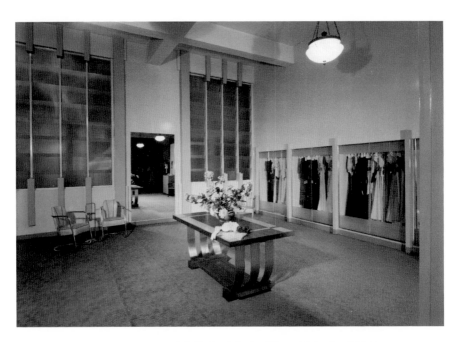

Auerbach's interior. *Herbert Auerbach Collection, Marriott Library, University of Utah.*

In 1946, Kimberly knitwear, founded by Jack and Helen Lazar, introduced sweaters and matching skirts made from 100 percent virgin wool, most of which were hand loomed and hand finished. By the 1950s, the manufacturer had added mixtures of wool and wrinkle-resistant Dacron blended with Orlon to prevent sagging. It expanded its product line with dresses, suits and coats and, as buyers of Paris originals, adapted couture wear to knitwear.

"After two decades of relative unease," Van der Wiel continued, "many people wanted stability, uniformity and the sense that all was normal. That 'normal' for some became the stylish perfect housewife in the suburbs—women who no longer had to deal with the financial difficulties of the Great Depression or the war years and could outfit themselves and their families in a picture-perfect high-maintenance style."

Generous full skirts attained the "just right look," and the lovely swish was aided by new versions of the bouffant net or paper nylon petticoats. The loose fit of the tent line duster coat, or Jacques Fath's "swing coat," was a fashionable silhouette for the high rate of postwar pregnancies. There were pencil thin tubular skirts, big skirts, tunic suits and boxy jackets with slim skirts and the sack dress by Givenchy, along with spiked shoes and ballet slippers. It was a new fashion world, again, designed for the elite and for the masses.

"As you might expect, the culture of conformity was eventually challenged throughout the 1960s. Teenagers wanted to be different than their parents. Women felt disempowered in the workforce after men returned from war, and many housewives felt confined in their suburban expectations. It was the perfect storm for another explosion of freedom," Van der Wiel said. "The freedom to express one's style was a reaction to the 1950s' sense of uniformity. Now the ideal fashion included everything from the highly patterned soft and flowing styles of the hippie look to the timeless miniskirts and the sharply graphic shapeless short tunics of those known as the Mods."

The 1970s, which fueled some of the "existential angst behind many of the new fashion choices, had eased," Van der Wiel said, "and people just wanted to have fun."

Suddenly, there were explosions of color, individual style and abundant choices, from the romanticism of Laura Ashley to Vivienne Westwood's street-inspired punk clothing and accessories.

"But when you look at pictures of fashion," Van der Wiel concluded, "you might want to remember Geoffrey Chaucer, who in the late 1300s intimated there's never a new fashion but it's old."

LOOKING BACK: "SHE WAS THE HEAD OF THE FLOCK"

—Tanny Stayner, Salt Lake City domestic engineer[45]

That woman people often talked about so glowingly, the one at the cosmetic counter at Auerbach's, was Maria Cairo, and she was stunning.

I had worked with Maria at Keith O'Brien's on Main Street when I was sixteen years old and attending the University of Utah. When she went over to Auerbach's, every time my mother and I would go in to shop, we'd see her. In fact, we'd always just go and wait for her by the counter toward the front of the store on Third South.

Maria was interesting, exotic and slender. She had this wonderful black hair that she did up in a bun in the back of her head, and she'd tuck into her chignon the most unusual combs. Some were exquisite, shiny ornaments on the end of long hairpins. Others were elaborate mantillas made of celluloid. When they rose high above her head so you could see them from a distance, they were so striking.

Maria Cairo and her mantillas at the counter near the front of the store on Third South Street. *Alexis Cairo.*

Maria was Greek, had very dark eyes that took everything in and was striking to look at. She wore very long earrings and heavy jewelry. She was dramatic. My mother and I loved to talk to her. She would show us different ways to do things: put a little white under your eyebrows to highlight your eyes and on the bottoms. And she had a type of makeup she sold us that was creamy with a kind of sheen that made your face look dewy and fresh— never overdone. It might have been one of their brands. My mother and I wore it all the time, and then they stopped making it, which was so sad.

Maria wore very high-style and fashionable suits and dresses. She was always put together with such sophistication in dress and attitude, and of course that beautiful makeup. She wasn't as old as my mother but quite a bit older than I—maybe in her fifties. It was hard to tell because she was so put together and always looked calm, humorous and helpful.

She had been there a while. I would say she was the head of the flock. She was definitely strong. I used to see her talking to buyers, gentlemen who came in with examples of cosmetics, and she knew what she was doing. She was head honcho. She would do the ordering. And did I say she was striking?

READY-TO-WEAR

I remember in the corner of Auerbach's, on the main floor, was ladies' blouses; downstairs in the basement, they had a little cafeteria where you could go and have lunch; on the mezzanine they had a candy counter, and upstairs right by the elevator you could get coffee.

My mother and I found this little lady in the ladies' ready-to-wear dresses. She was so attentive when she waited on us. We could go home and call her and say, "Do you remember that dress? Would you have it sent out to us?" And it would be delivered.

Everyone dressed really quite nicely at the store: the people working there and the customers. My friend and I always dressed up to go shopping. I'd wear a white blouse, say, and a skirt with high heels. This was a time when women were still conscious of what they were wearing.

In those days, everyone dressed smart when they traveled by air. On my first airplane ride I took to Richmond, California, I wore a Kimberly knit dress with a jacket from Auerbach's and in my suitcase had packed another Kimberly three-piece, skirt, tank and jacket.

Auerbach's attracted the rich and famous. They had some expensive things, and they had things you could afford that were really upscale. I was going out on a date and wanted a little black dress and found it—just exactly. Shoes and the millinery were on the second floor, and as far as hats! More often than not, we'd try them on whenever we could and end

up buying a hat. We kind of liked a new hat once in a while to wear at St. Mark's Church.

Auerbach's is where I started wearing that luscious perfume Odalisque. When they closed the store, it was a rude awakening and sad. For so many of us who shopped there, I don't think we could ever forget Maria Cairo—or Auerbach's.

Part XIV

TAKING IT TO
THE NEXT LEVEL

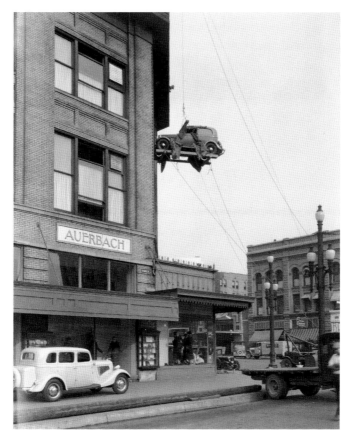

A car being hoisted up the Auerbach building for display. *Utah State Historical Society.*

GEORGE S. AUERBACH, ENTREPRENEUR AND WORDSMITH

Born in 1885, Samuel's middle son, George, received most of his education abroad. He attended elementary school in Germany and Switzerland, later graduated from Columbia University in New York and returned to Salt Lake to join his brothers Herbert and Frederick in running the Auerbach store. In 1909, Samuel and Eveline moved to New York City and left George to run the store. And George loved every moment of it. He believed Utah was truly the crossroad of the West, and Auerbach's presence was its magnetic jewel.

According to the November 14, 1927 *Salt Lake Telegram*, George "took over active management, and under his guidance the business expanded and moved from its original location on Main Street to State Street and Broadway in the building now occupied by the Auerbach Furniture annex. Later the department store moved across the street in its present location."

A MARRIAGE BETWEEN TWO PROMINENT RETAIL MERCHANT FAMILIES

When George was young and trading in stamps, Samuel worried about his son's lack of letter writing. He needn't have. Once the man fell in love, there was no stopping George from putting pen to paper.

In 1907, Samuel and Eveline took several of their children—including George and Frederick—on an ocean voyage to Norway. While on board the

SS *Olympia*, twenty-two-year-old George was intrigued with fellow passenger Beatrice Fox. He later informed his mother that the young lady was the woman of his dreams and someday he would marry her.

Beatrice was the daughter of Moses and Theresa Fox of Hartford, Connecticut, who owned G. Fox & Co., which in the 1950s would become one of the largest privately held department stores in the country. From a young age, Beatrice and her sister Fannie (accompanied by the children's companion) were taken on many trips abroad by their parents.

Moses believed that exposing his children to different worldly cultures and traditions was the ultimate education. By the time she was eleven, Beatrice was filling pages of travel diaries with destinations and experiences. She, too, liked to collect stamps. And in the end, she loved George. Smitten with one another, they wrote almost daily; George posted more than 150 letters.

ADVENTURES IN RAILWAYS

In one missive, George declared his love of railroads and a desire to own one. He told Beatrice not to worry about reports of train robberies, although she may have had cause.

On February 21, 1910, the *Deseret Evening News* reported, "Three outlaws from the United States, among whose names were at one time upon the tongue of every person in the Rocky mountain area, have taken up residence in the Argentine Republic; and are leading a band of brigands so powerful that the government itself is forced to pay them tribute." In America, having "preyed upon the railroads," Butch Cassidy, the Sundance Kid and Kid Curry (Harvey Logan, known as the leader of the "Wild Bunch") were outside the law of the land. And as for Kid Curry, "it was said the Union Pacific railway alone has spent $500,000 in trying to capture him."

Closer to home, the June 27, 1910 *Ogden Standard* wrote, "The daring holdup of an Oregon Short Line train at 1:35 this morning, within the city limits, is a climax to a series of robberies, holdups and murders which have kept the peace officers of Ogden and Salt Lake City on nervous tension for six months past." It added, "If the outlaws in the train robbery are outsiders, wholly unknown to this section, then they are the most daring, reckless, resourceful desperadoes ever within the boundaries of this state, surpassing Butch Cassidy and his gang in boldness."

And He Also Sent Her Love Letters

On December 31, 1910, George wrote:

Beatrice, you are so full of fun and life and so loveable and such a dandy girl....Let me rave, it does me good to get it out of my system, but aside you, my own sweetheart, know that Salt Lake is so situated as to be the central point between the East and the West, and some day we shall see the most wonderful change in this. It will be a second Chicago as far as a railroad center is concerned. Why, just stop and figure how many railroads leave or enter this city today....There is a road to Los Angeles, two roads to San Francisco, one to Spokane, Portland and Seattle, and to Butte and to Logan and southern Idaho; one to Denver, one to Chicago, one to the Park City mining district, one to the Bingham mining district, one to the Eureka mining district and to Richfield, one to Manti. These are all separate tracks that meet in Salt Lake. Then the street railway company has suburban cars to Murray and Sandy, and the Bamberger line runs to Ogden.

Say, if I was writing a prospectus, and you were to read it, never having been out here, don't you think you'd fall for it and wonder and think of it? You'd begin to feel that the railroad people regard our beautiful city as the center of the USA and that with time all business from the East to the West, and visa versa, would have to bear our stamp of approval....Well then, come and join us in our beautiful community of mutual good interests.[46]

In a Spate of Words

Among copious letters and postcards, George mentioned he was due on the sales floor during Auerbach's Christmas Eve rush, when the store stayed open until 10:30 p.m. "You know the last customers are the best ones," George wrote. "They haven't time to shop, and they usually buy the best things."[47]

He wrote saying he was giving up cigars and coffee, and worried about Beatrice giving up a fortune and marrying out of her class. Despite his family's large amount of property, mining stocks and the dry goods business, the Auerbach estate divided among eight siblings, he explained, would not leave them "a big fortune." He believed Utah would profit "enormously" when trains brought people through Salt Lake City on their way to the 1915 World's Fair (the Panama-Pacific International Exposition) in San Francisco.

He sent Beatrice schematics of apartments she might like; thought he might go after a law degree; and as for entertainment in Salt Lake City, well, there were "first-rate playhouses," such as the Colonial Theatre, which, at a cost of $150,000, was built by the Auerbach brothers in 1908. Most of all, not wanting to disappoint Beatrice, George asked her to freely ask him anything about life in Utah—anything at all.

A WEDDING

On August 10, 1910, George and Beatrice announced their engagement. And on April 5, 1911, they were married at the St. Regis Hotel in New York. It was an evening ceremony led by the Reverend Dr. Henry Ettleson, from Congregation Beth Israel in New York. Beatrice's sister Fannie was her maid of honor, and George's brother Fred was the best man. The bride wore "a gown of raw white silk, trimmed with real point lace."

Beatrice Fox and George Auerbach's engagement. *Koopman Family Collection.*

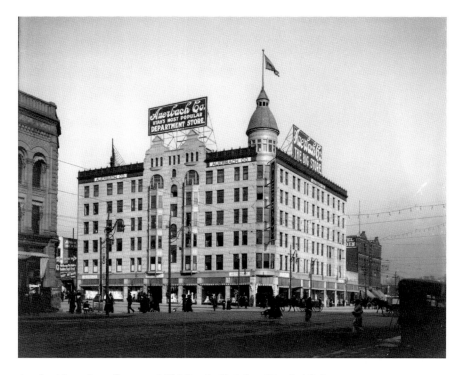

Auerbach's on State Street and 300 South. *Utah State Historical Society.*

Returning to Salt Lake, the couple attended services at Congregation B'nai Israel. Beatrice made friends among the members of the Mormon community. George supported the city's newspapers, such as the *Salt Lake Herald*, the *Deseret Evening News* and the *Salt Lake Tribune.* He became a director in the Walker Brothers' Bank; was active in outdoor sports, such as duck hunting and fishing; took up boxing; looked at land purchases; and, with his brothers, looked forward to further modernizing the Auerbach's Department Store.

A CALL TO HARTFORD

In 1916, their daughter Georgette was born, followed by Dorothy in 1919. But in 1917, the new family was called back to Hartford. In January that year, a fire had broken out on the main floor of the G. Fox & Co. building and spread quickly. Burning for some eighteen hours, it devoured the brick, wood and metal building.[48]

George Auerbach and his daughters, Dorothy (*standing*) and Georgette. *Koopman Family Collection.*

Moses Fox, whose immigrant father had started the original business in a two-room storefront in 1847, knew he would have to begin again. The company hired architect Cass Gilbert, a skyscraper pioneer, who designed New York City's tallest building, the Woolworth Building, in 1913. Moses needed his family, in particular Beatrice and her husband, George, to anchor G. Fox & Co.'s success.

Fueled by his Auerbach experience and ethics, George went to work. According to the November 15, 1927 *Salt Lake Telegram*, his first responsibility was the "superintending of construction of [the] eleven-story building." He became the secretary-treasurer of his father-in-law's store, was quickly known in Hartford as a "civic-minded" executive, was an incorporator of the Hartford National Bank and, like his uncle Frederick before him, was an active Mason. He was also one of the founding members of the Tumble Brook Country Club. Organized in 1922, the club was formed largely by members of a Jewish social group known as the Touro Club responding to the exclusion of Jews in many country clubs in Hartford, in this case, and across the country.

Always on the lookout for property, George and Beatrice bought a working farm in nearby Bloomfield, Connecticut, and called it Auerfarm. In summers, they took refuge from the high stress levels involved in building a successful retail business. In 1926, George and family—taking along trip diaries—went abroad but not far enough away from business issues. In 1927, George, who suffered often with abdominal pains, was taken to a Hartford hospital and, possibly misdiagnosed, died.

Almost immediately, and inconsolable, Beatrice became the executive of her father's business and a caring homemaker for her children. When Moses died in 1938, Beatrice became the chief executive and ethical leader of the landmark firm G. Fox & Co.

"Reading their letters, and from what we heard, Beatrice and George certainly loved each other," said her granddaughter Rena Koopman.[49] "When my grandmother started running the store, after the fire, I imagine there weren't many men who would see her as an equal partner, but George did; and probably did from the first time they met."

Although Beatrice did not have a traditional education to prepare her to run a department store, Rena said it would have been in her genes. "She had an innate brilliance and sense of how to conduct herself, how to talk with others and how to work," Rena said. "She had vision, and she made things happen."

"My grandmother goes downtown, takes up the business, discovers she really likes it and makes it bigger," said Rena's sister Brooksie.[50] "But she didn't stop there. She created an employee cafeteria similar to the farm-

to-table principle. She hired and promoted minorities, including women, and put them in positions of power. After World War II, she talked with psychiatrists, social workers and doctors, trying to find the best ways to reintegrate former employees—many returning without limbs and all of whom she had promised jobs—back into her workforce."

"One of her best friends was Eleanor Roosevelt, and these women really had vision," Rena said. "They were far-seeing, and they got things done."

Beatrice loved George and never remarried.

LOOKING BACK: "FROM GO-FERS TO MODELS"

—Liz Keller, former airline stewardess, Salt Lake City[51]

My family moved to Salt Lake from Oklahoma in 1941, right before the war, and I shopped at Auerbach's before I started working for them. I was nine years old and with my mother, who loved to shop there. In fact, I can remember we would start at Auerbach's, then go to the Paris, cut through Woolworth's to Main Street and walk up to a women's store called Miriam's, next door to ZCMI, and then to Makoff's on State Street. The next time we were downtown, we'd take the same route.

WE WERE GO-FERS

When I was seventeen years old and a student at the University of Utah, I worked part time at Auerbach's and went wherever they put me. We were considered go-fers. I was under a woman named Mrs. Cashman. She was a small woman, I'd say petite, and dressed smartly in a suit or a one-piece dress with a sweater or a jacket, two-inch heels but never flat shoes. She was impeccably groomed, never a hair out of place. A good person to be in charge: she was not overly friendly; she didn't fraternize. She came and made sure you were doing your job and you were well groomed too. We thought she was pretty stern. But she knew what she was doing. Auerbach's would only have merchandise upstairs for so long, and if it didn't sell in a year, it would be marked down and brought downstairs to the

Everything a college girl wants. *Utah State Historical Society.*

bargain basement. There was wonderful stuff there, and the basement was always picked over. Mrs. Cashman wanted us to go around constantly straightening up and folding.

If Mrs. Cashman wanted something moved upstairs, we did that. Or from the upstairs to the downstairs, we did that. We were kind of at her beck and call. We wore our regular clothes because we were always running and back and forth from school, too. I loved the jewelry counters on the main floor. You had costume jewelry in one section and your better jewelry across the aisle in a different display counter. And Utah, known for its sweet tooth and number one in sugar production—a lovely candy counter was right in the middle of the store.

All the men who worked in the men's department wore suits or sport coats and looked dignified and informed.

HATS AND MORE HATS

At the better hats department upstairs, everyone wore suits and dresses. It was different downstairs at the hat bar because I was a student and wore a skirt and blouse but never wore high heels. There was the unforgettable hat bar at the end of the jewelry counter, with all those little fun hats, like berets, hanging on a wall.

But your more expensive hats were always on a mannequin head. The women who worked in the hat department had been there for a number of years. Each had a special relationship with their customers who would come in, particularly, just to see her. Serious shoppers would look at the hats that were displayed, and if they didn't see anything they liked, the saleswoman would go into the back stockroom and bring out some hats she thought they would. When new hats came in, the saleswoman would call her customers if she saw something new that they would like.

There was a cashier at a counter in an area in front of our stockroom. The women working in the hat department would go back to the cashier to write up the sale. If the transaction were done in cash, she would give it to the cashier and return any change with a receipt.

They were cute little hat ladies. The women mostly wore knit suits. They always wore nicely tailored suits and were very professional looking. "Hello, Mrs. Walker," one might say. "Oh, it's so nice to see you today. I have just the thing that came in that would look just wonderful on you."

ADVANCEMENT

I worked from the basement up to the second-floor hat department for a man whose name was, I believe, Mr. Firth, who was head of the hat department. When hats came in, Mr. Firth would give me the prices, and I'd mark them on the tags and attach them to the inside headband with a little needle and thread. Mr. Firth was very fussy about how you put the price tag in through the inner band. It had to be in that inner band. And we also had to tuck the price tag up inside the hatband so

it didn't hang down. So when women tried on the hats, they didn't see the price tag hanging down. They would have to like the hat first before seeing the price.

The hat department was quite a fancy department. It had individual dressing tables with exquisite mirrors. The person would be escorted to a table and sit down, and the saleswoman would place the hat the way it was supposed to go—whether it was flat on her head or tilted back or whatever it was—and be honest and kind in saying what looked good on her and what didn't.

Mr. Firth was a very tall and lean gentleman who always wore an impeccable suit, shirt and tie. He would never wear a sports coat—always a matching suit. He had a full head of steel gray hair combed to the side, and he wore glasses. I can see him even now. He was an incredible and attentive salesperson. He just knew how to handle those ladies who had lots of money who would come and buy beautiful and expensive hats. You can't be overbearing, and he was never overbearing.

THE ELEVATORS

I ran the elevators. As I recall, I wore a white blouse and a black skirt and white gloves. I remember it took me forever practicing to get the elevator floor absolutely even with the store floor. First there was a gate you would slide open or close, then you pushed a lever forward to go up, pushed it back to go down, and when you stopped at a floor, the lever would be centered and you would be level with the floor as you opened the door and gate with your white glove and said, "Second floor, Better Dresses and Hats."

SECOND-FLOOR FANCY

Chandeliers lit from above, large carpeted dressing rooms with mirrors, hushed tones, high-fashion dresses, gorgeous fancy clothes, special clientele and salespeople who were always dressed in very tailored suits created an ambiance of sophistication that made you think of New York and even Paris.

Left: Eighteen-year-old Liz Keller (right) models in an Auerbach's newspaper ad. *Liz Keller.*

Right: Modeling at Auerbach's was an experience for the teenage miss. *Liz Keller.*

I think most of the buyers went to New York twice a year to the shows. And I remember Frederick [Fox] Auerbach [see following chapter] would come into the store quite often and go from department to department, not only to check on every department, but also the people working for them: that they were dressed appropriately and not wearing too much makeup. The Auerbachs were very particular about how their salespeople looked and represented the store. So much was subtle.

AN AUERBACH EDUCATION

Working at Auerbach's was educational in lots of respects. I was taught how to interact with people, especially older women, and the importance of respecting your customers. I also learned about fashion. I was about eighteen or nineteen when I modeled for Auerbach's. I did some in-store modeling and

for ads that would go into the newspaper. I think it was Walter Lillian who photographed us for the paper. In fact, he did my wedding pictures.

Ruth Tolman, who worked at Auerbach's, taught me how to model. She taught me how to walk, stand, pause and turn. When you paused slightly to show an outfit in a small room on the second floor, you would stand in one way. When you were doing runway work, it was like being on a narrow plank. You would take a few steps and stand in another way, poised but making sure your footing was just so.

She would say, "Don't swing your hips; that is so vulgar!" And, "Always hold your head up if you want to have a graceful swanlike neck." And I'll say this for her. By the time she was done with us, we learned to be a little more self-assured and walked very nicely with our heads high.

FROM "SILENT SERVICE"
TO SECOND-GENERATION "MR. FRED"

W hile George Auerbach was falling in love with Beatrice Fox on board the SS *Olympia* sailing to Norway in 1907, his seventeen-year-old brother Fred and eleven-year-old Fannie, Beatrice's sister, chatted onboard as youthful pals accompanied by their parents and the child's chaperone. In 1925, brothers to sisters, they, too, married.

Frederick grew up in his father Samuel's mercantile business. Educated in Europe and New York, Frederick graduated from Cornell University, stayed on the East Coast and worked at various department stores and trade centers to develop a broader understanding about merchandising. During World War I, he served in the United States Navy, known as the "Silent Service," in Brest, France.

Returning to Salt Lake City, "Mr. Fred," as employees fondly called him, resumed his executive position at the store. He was vice president, secretary and treasurer of the Auerbach Company; his brother Herbert was president. Together, they complemented each other and took charge to strengthen their holdings in the family's concern. Fred was also interested in real estate, mining, gas and oil operations and rare stamps and coins. "He owned valuable collections of both," the June 1, 1938 *Women's Wear Daily* mentioned. "His interest was recognized by the American Numismatist Society with an appointment as district secretary of the organization."

In their new location on Third South and State Streets, the brothers added to the character and appeal of their father's department store. Frederick made frequent trips to the East Coast, each time choosing new

Right: Frederick Auerbach in the United States Navy, 1918. *Koopman Family Collection.*

Below: Auerbach's fleet of delivery trucks, 1925. *Utah State Historical Society.*

and timely items from high fashion to fashionable wears to better focus the store's merchandise.

On June 16, 1925, Fred and Fannie Fox were married at Temple Beth Israel, one of the largest Reform Jewish congregations in Connecticut. "Her wedding dress [was] white satin embroidered with silver and pearls and she [had] a court train of cloth and silver embroidered in pearls," the June 16, 1925 *Hartford Daily Times* reported. "She [wore] a veil of tulle and rose-point lace draped with orange blossoms and carried a bouquet of orchids and lilies of the valley."

Herbert was his brother's best man. Fannie's sister Beatrice was the matron of honor, and her children, Georgette and Dorothy, were flower girls, each carrying a lavender basket of spring flowers.

The new couple lived in Salt Lake City; their home, on Military Way, was grand. Their active social life was one of warmth, charm and hospitality.

There was no doubt whether choosing European imports or Parisian couture; Fannie was always dressed to the nines. "My Great-Aunt Fan never worked like her sister did, but they both dressed beautifully," Rena said. "Yet whatever Fan bought, tailors would have to fit it to her because she had

Fred and Fannie's home on Military Way, SLC. *Koopman Family Collection.*

The elegant Fannie Fox
Auerbach. *Koopman Family
Collection.*

such a small waist. In fact, I have two gorgeous skirts of hers—one with at least a thousand pleats in it—that I still can't bear to give away. As for shoes, remember, this was during the era when your shoes were dyed to match your dress. And Fannie always had two dyed pairs of shoes, just in case…"

Expanding Appearances

By the late 1930s, Fred and Herbert had display windows that were scenic and fashionable and ever-changing showcases, most the work of talented display artists and seamstresses. Eventually, a modern soda fountain with handsomely upholstered stools and an attentive wait staff attracted bevies of diners.

Most stunning was a rush of 1934 Ford-V-8 ragtops and coupes that were perched high up on platforms secured to the exterior walls of the Auerbach

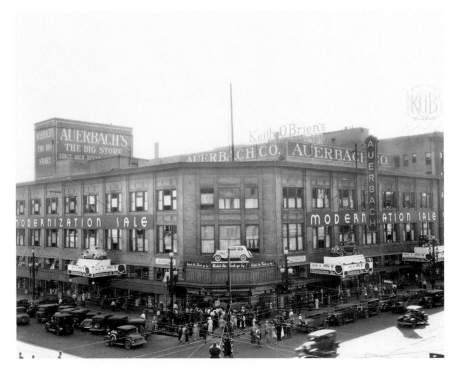

A modernization sale, 1934. *Utah State Historical Society.*

building. Like a string of sparkly automotive paint-and-metal pearls, they captured the eye of every passerby. Stopping in their pedestrian tracks, one could not help but look up in amazement at the sky-high automobiles before making a sharp left (or right) turn into the store. According to Chris Smart's article in the May 8, 2016 *Salt Lake Tribune*, Utah historian Will Bagley's grandfather won one such Ford in an annual Auerbach raffle.

Advocating the pioneer brothers' appreciation of their store employees, Frederick, George and Herbert ensured Auerbach's continued success by recognizing the excellence, dedication, enthusiasm and growth of the store's workforce under their charge.

"[Frederick was] a man to whom the employees could go with [their] greatest perplexities and find him eager and ready to offer advice and counsel," the June 1, 1938 *Women's Wear Daily* wrote. "He sought always to be helpful and constructive."

Humor abounds in the Fox Auerbach home. Young Frederick and his pals! *Koopman Family Collection.*

A young Frederick Fox Auerbach.
Koopman Family Collection.

LIFE

On July 12, 1927, third-generation Frederick, "Freddie" Fox Auerbach, was born to Frederick S. and Fannie, and life looked good for the young lad, who was loved and cared for in a family where style thrived with humor and goodwill.

But on May 28, 1938, his father, forty-seven-year-old Frederick S., suffered a fatal heart attack and died on Saturday morning at the family's residence on Military Drive. Freddie was nearing eleven.

"WE HAVE LOST A GREAT AND GOOD FRIEND"

"Hundreds of business, civic leaders and friends filed past the bier of their associate, Frederick Samuel Auerbach, whose body lay in state in the Assembly Hall on the L.D.S. temple block prior to funeral services," the May 31, 1938 *Salt Lake Telegram* reported. Temple B'nai Israel, where Frederick was an ardent member, was too small to hold such numbers.

Responding to the "exemplary citizen's" sudden death, several downtown businesses closed early so their employees could attend the funeral. "Officiating at the services was Rabbi Samuel H. Gordon of Temple B'nai Israel; burial to follow the services in the Auerbach family vaults in B'nai Israel cemetery." There, full military honors were accorded "by a firing squad from Fort Douglas."

Herbert was on a business trip in Los Angeles when he heard of his brother's death and rushed home. The family was devastated.

HERBERT S. AUERBACH, UTAH'S BELOVED SON

A RENAISSANCE MAN

In 1897, Samuel's third son, Herbert, was a fourteen-year-old student at the Fresenius Chemical Laboratories in Wiesbaden, Germany. He later studied at the Conservatory of Music and Lausanne Technical School in Switzerland, spent a year touring the concert stage in Europe as a violinist and in 1906 graduated from the Columbia University School of Mines in New York City with a master's degree in electrometallurgy. After managing mining properties in Idaho and Colorado, in 1911 he joined George and Frederick in running the family business.

Serving on the board of regents of the University of Utah in 1917, Herbert resigned to enlist in the army during World War I. He was a major in the Ordnance Department until 1919 and on his return was a member of Salt Lake Post No. 2, American Legion, the Alta Club, Rotary Club and Chamber of Commerce.

Herbert was fascinated with history. He served as the vice president and president of the Sons of Utah Pioneers and was a member of the Utah state legislature (1925–29). He also wrote music and poetry and composed religious songs with Anthony C. Lund, director of the Mormon Tabernacle Choir; contributed stories about the West; and translated Father Escalante's journals written during the 1776 Dominguez-Escalante Expedition.

Herbert never married and resided in the Brooks Arcade on 268 South State Street. At the mouth of Big Cottonwood Canyon, he, too, like his

Herbert Auerbach off on an adventure. *Herbert Auerbach Collection, Marriott Library, University of Utah.*

In an Auerbach window display, "You Danced that Last Waltz with Me," lyrics by Herbert Auerbach. *Herbert Auerbach Collection, Marriott Library, University of Utah.*

Herbert Auerbach (*middle*) at the opening night of the Centre Theatre, 1937. *Herbert Auerbach Collection, Marriott Library, University of Utah.*

brother George, had a farm, called Meadowbrook ranch, where he grew vegetables. In memory of his parents, who in the spirit of *tzedekah* gave to those in need, he donated pounds of homegrown produce and other items from the Auerbach's grocery store to the elderly during the LDS-led "Old Folks Day" in Salt Lake's Liberty Park. He specialized in beautiful breeds of poultry, grew fruit trees and collected cairn terriers.

And, like George, Herbert loved the theater. In 1937, he designed and built the Centre Theatre on State and Broadway, an Art Deco–style building with a looming ninety-foot tower in the front, kitty-corner from Auerbach's. The December 23, 1937 *Deseret News* reported the theater offered "the newest and most perfected projection and sound reproduction equipment; the finest acoustics; perfect vision from every seat; and uniform all-year air conditioning."

OH, THOSE BLOOMER GIRLS

When women's sports in Utah were mocked as being more entertainment than sports, Frederick and Herbert had a chance to stand up for women's rights in 1935—even those that came with a bat. A group of female Auerbach employees asked the personnel manager, Dennis J. Murphy, if he would become the team's manager and coach if the company were to help sponsor a women's softball team. Murphy agreed, and for thirty-two years, "Mr. Softball" maintained his position.

The women called themselves the Auerbach Girls. Later they became the Shamrocks and were recognized as the "matriarch of organized baseball teams in Utah." Soon after, the hackneyed perception of the female athlete struck out.

"The girls traveled from coast to coast, and from Canada to Mexico, sometimes racking up ten thousand miles in a season," Twila Van Leer wrote in the January 14, 1996 *Deseret News* article "Shamrock Baseball Team Laid Snide Remarks to Rest." "The team didn't just exist. It won an amazing percentage of games it played. And sometimes when sponsors were in short supply, the wherewithal to keep the team afloat came from the pocket of the Auerbach's personnel manager, Dennis J. Murphy."

AFTER THE LOSSES

Herbert threw himself into operating the store, as there was no way to go on but to keep going. He worked with Leslie R. Samuels, a well-known retailer in Ogden whose famous shoe store, which drew in customers from all around the western region, evolved into a flourishing Auerbach's department branch store. While running his Ogden store, Samuels had lived in the top floor of the Ben Lomond Hotel. Integrating fully with the Auerbach Company in its downtown store, Samuels fell in love with, courted and married Frederick's young widow, Fannie. He doted on Freddie.

"My great-aunt's second husband, Les Samuels, was by all accounts a brilliant retailer," Brooksie Koopman said. "He was in charge of the women's shoe division of the Office of Price Administration during World War II, and in terms of finances and all that, Auerbach's was in exceedingly good hands when he was in charge."

Auerbach's continued fine-tuning its store, its merchandise and its reputation. Its advertising promotions increased sales, and it was business

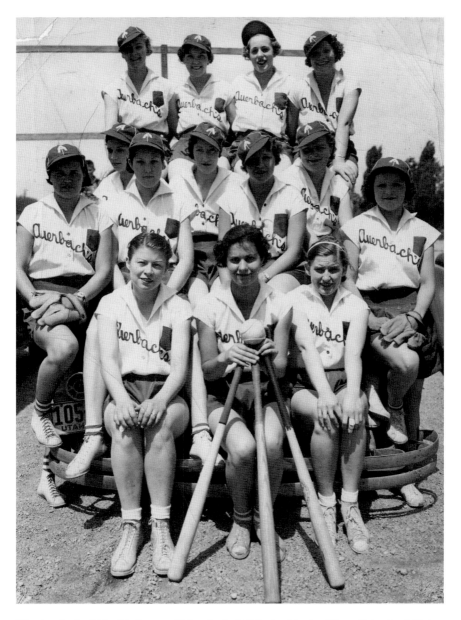

The Auerbach girls' softball team. *Herbert Auerbach Collection, Marriott Library, University of Utah.*

A scenic Auerbach's window display. *Herbert Auerbach Collection, Marriott Library, University of Utah.*

Pearl diver and pearl jewelry window display, 1929. *Herbert Auerbach Collection, Marriott Library, University of Utah.*

not as usual but better. In 1944, Auerbach's published an oversized catalogue called *Eighty Years of Service: The Frontier Store of the Rocky Mountains*. Illustrating store interiors, historic scenes of Utah history, pony express stations, tithing books, mule-drawn streetcars and "the kissing of the locomotives," Herbert wrote:

> *Eighty years is a long time in any man's lifetime, but it is a particularly long time in the life of a business concern….Auerbach's eightieth anniversary attests the integrity of our mercantile policies, our ideals of service to this community, and our ability to progress with the changing conditions of our eighty years of life, thus establishing and maintaining a reputation as one of the West's great department stores.*

In conclusion, he wrote, "You, our customers and our faithful associates and employees, are, of course, the ones who have made such a long and successful business career possible.…In the years to come, we will, as in the past, strive to maintain your confidence and good will."

"TO EVERY HEART
MUST COME SORROW"

started out there as a stock boy when the war broke out," said Kenneth DeConde, owner of the DeConde's fine furniture, accessories and interior design store in Salt Lake City.[52]
"I was about fourteen years old. I worked in the basement of the Victory Theater, which the Auerbachs owned, and balanced out the leather shoe stock with shoe stamps, which were like wartime rations, until we had no leather shoes to sell."

Ken DeConde, whose father worked as a structural and remodeling engineer for the Auerbach Company, had to search for alternatives. "This was during the summer," he said, "so I went to the basement and returned with Keds, which were rubber and canvas, and galoshes and wedges. I then arranged them on large inviting display tables to show we had products that were not made of leather and were still in fashion."

Wedges, created by Italian designer Salvatore Ferragamo in 1935, were made of cork, wood and natural hemp for the uppers. They were comfortable, sturdy and lightweight. Besides offering tone to the leg, wedges adhered to the WPB's Limitation Order, were popular during the war years and have returned in style today—with or without the 1970s design featuring plastic goldfish in the heels.

"At the time, Mr. Samuels, who was the manager of the store, taught me how to stage shoe promotions, purchase shoes accordingly (eighteen pairs at a time and multiples of eighteen) and gave me the creative space to promote shoes in a window display."

In designing a series of pointed high heels all in the same color, DeConde hung each shoe with precise ascending and descending lengths of clear

fishing line. "It looked as if the shoes were going up and then down invisible stairs," he said. "It was a difficult but handsome display."

Rewarded for his artistry, the young man soon was promoted from "stock boy to assistant manager of a little shoe department by the elevator on the third floor."

A GOOD MAN

Herbert and Mr. Samuels had the store well in hand when sixty-two-year-old Herbert, after feeling ill for several days, died of heart disease on March 20, 1945. His sister, Madeline (Auerbach) Werner, was by his side.[53]

"A native son of pioneer parents, Mr. Auerbach's talents and accomplishments were broad and diversified, but he cherished most his early western heritage and that led him to devote much time and effort to building the Intermountain West industrially, culturally and esthetically," the March 21, 1945 *Salt Lake Telegram* reported as it extolled Herbert's accomplishments, contributions and business affiliations.

With so many people wanting to pay their respects, the final rites for Herbert, like Frederick, were conducted in the Assembly Hall on Temple Square, with services led by Rabbi Alvin Luchs from Temple B'nai Israel. Accompanied by the Tabernacle organist Frank W. Asper, Jessie Evans Smith sang "To Every Heart Must Come Sorrow," with music and words written by Herbert S. Auerbach.

"Herbert's success in life was attributed by his rabbi to his instinctive quest for 'Those things which unite men, rather than the difference which breaks them up into sects,'" wrote historian Miriam B. Murphy in the 1945 issue of the *Utah Historical Quarterly* 13.

Herbert listened to his father's stories and, so engaged and wanting to know more, encouraged Samuel to write his memoirs. It was a gift Herbert took to heart. Much like his father, he loved to write and live every aspect of his life as if it were a most telling adventure.

BLACK WREATHS FOR HERBERT

"I helped the floor manager hang the black wreaths at the two entrances to the Auerbach Company, the Brooks Arcade and on doors," DeConde said. "He [Herbert] was a wonderful man. He wrote beautiful hymns and show tunes, had a vast library of music. One of the window displays showed his

work. His apartment at the Brooks Arcade was furnished with very French pieces. He would entertain with parties. He was nice, smart and funny. Girls always liked him. (Oh, honey, this list could go on forever.)

"Until young Freddie was old enough to operate the store on his own, he was with his stepfather, Mr. Samuels, who really tried to teach him everything. I remember Mr. Samuels managed the store from both New York and the Hotel Utah, where I believe they rented so many rooms and furnished it to their liking," DeConde said.

"Mr. Samuels was very involved with the store and remodeled constantly. The big joke was that people would come in and ask where such-and-such department was because it certainly wasn't where they found it the last time. He must have [moved] it over the weekend. His business ethics were really high."

When Mr. and Mrs. Samuels traveled to Paris on buying trips, DeConde said they would always return "with Parisian original gowns that we'd feature in the Broadway window on Third South Street. They had exceptional taste, and Mrs. Samuels always came to the store well dressed and stunning."

NEW YORK TRADE SCENES

In 1948, nineteen-year-old DeConde became the youngest buyer in the store. "Mr. Samuels sent me off to New York, and I learned not just 'where' to and 'what' to buy, but 'why' buy it in the first place," he said. "The New York trade scene was exciting. The town was always busy. I remember Mr. Samuels taking me on a tour and watching him work with vendors, and just how aware he was—well, it was a great education and gave me a good footing when I went off on my own."

THE LAST HEIR

"I remember Freddie," DeConde added. "He was personable, a real fun fellow and likeable, although shy at first meeting. He really loved the outdoor world, sports and deep-sea fishing. Under Mr. Samuels's tutelage, Freddie took on the responsibility of the store, and he was a wizard in many ways. He would watch out for the buyers' allowances that we were given to see that we stayed within the allotted budget. And he was amazing with figures, absolutely unbelievable. He could take three or four columns of figures and—whoosh!—add them up in his head, just like that."

LOOKING BACK:
"BEAUTIFUL. EXPENSIVE. CLASSIC. AUERBACH'S"

—Beverly Frank, jazz singer[54]

When I was born, I was called the "Wonder Child" because my closest sibling was twenty years older. My dad died when I was three, and I think what that did to me was to make me very independnent. I was determined, as young as that, to be independent.

"FLY ME TO THE MOON"

I was raised in Utah on that American songbook with all the standards, like Cole Porter, Peggy Lee and Frank Sinatra. And I loved to sing. My sister Winnie, who had been the head hostess at the Hotel Utah for a long time, used to say, "Sing, Bev! You gotta sing!"

So when I was seventeen, I won the nationally broadcast *Ted Mack Amateur Hour* and hosted a half-hour daytime show called *The Bev Jensen Show* in Reno, Nevada. Sponsored by Hoover Vacuum, I opened with "This Is a Very Special Day" and, accompanied by a piano player, often sang "Fly Me to the Moon."

From there, I went to Los Angeles, got a job at CBS Television City on La Brea and Fairfax Avenue, where I did walk-ons, but I wanted to sing and record, so I went to Capitol Records. Glenn Wallach, who co-founded Capitol Records with Tin Pan Alley singer-songwriter Johnny Mercer, gave me a job at the switchboard in their newly built Capitol Records Building on Vine Street and opportunities to record.

From then until I returned to Utah, I did gigs singing with little jazz bands; recorded "Go Home, Cheater" for record producer Gary Paxton, which was a hit. Everything wonderful was happening, and I even modeled for hair products, shoes and David Crystal suits for women.

It was a wonderful time, and I met a lot of people: singers, actors, comedians and producers. I married my best friend and agent, and we had a little girl. When she was three, her

father and I divorced, but we remained good friends. He was a wonderful and talented man.

When I started to think about my darling daughter, I thought we would go back home to Salt Lake City and I would figure out what to do next. That's when Auerbach's came into my life.

David Crystal was in town showing a new line at the Hotel Utah. He knew I had moved back and called to see if I would be able to model some of his clothes there.

Fred Auerbach was at the show with Mr. Samuels. Fred loved the David Crystal line—it was a really hot line with beautiful fabrics. He asked if I wanted to open up a boutique. He had a specific place designed for the Crystal Room, with the boutique already in place. I knew fashion all right, but I never sold as much as a handkerchief. I was thrilled about the opportunity.

Auerbach's was an elegant store. The second floor was the shoe department and better sportswear. From there, you'd go up the stairs into a beautiful red carpeted room called the Crystal Room, enclosed within a half circle, and that's where all the designer clothes were kept.

I vividly recall working with Ruth Collipriest, the Crystal Room manager and buyer, because she had such great fashion sense and bought all the exclusive beautiful dresses in the Crystal Room.

I handled the boutique department—it was on the second floor by the elevator (the escalators came soon after). I bought accessories, perfumes like Christian Dior, exquisite scarves, top-of-the-line jewelry and handbags. Salt Lake was just waiting for these gorgeous things. I sold them like crazy.

At first Fred would come into my little office, which was like a place off the shoe department, to see how I was balancing the budget. I did balance it, all the time, and I made a profit for the boutique.

The first time I went to buy in New York, I went with Mrs. Collipriest and stayed in the Manhattan Hotel, which was a reasonably priced place and where most of the other buyers stayed. You know, we were all living on a budget. Mrs. Collipriest then took me to the Seventh Avenue market, where I was given the names of different vendors that might have the merchandise I needed. Eventually, I knew where to go, especially for my clientele that wanted those one-of-a-kind items.

Beverly Frank on a New York buying trip for Auerbach's. *Beverly Frank family collection.*

I remember when Jeanné Wagner, wife of Salt Lake businessman Izzy Wagner, came into the boutique carrying a picture of a gorgeous Mondani bag and asked if I had anything like it. I said no, but I was going to New York next week and would see if I could find it. And if I did, I'd call. And I did. She was darling and appreciated me a lot. I loved working at Auerbach's. There wasn't one floor that wasn't decorated beautifully. I remember at Christmas, Utah singer and actor Robert Peterson would sing in his most beautiful classical voice. It was a celebration just to hear him.

But I remember meeting Mr. Samuels at the Hotel Utah. He was a very sophisticated and gentlemanly kind of person with the very best of manners and an elegant attitude. I do believe he was the one who said we needed to have a spark at Auerbach's, and he wanted that boutique to be something that people came to see. And I understood. He knew what he wanted, and what he wanted was a little more New York, a little more class. I think we gave that to him.

OVER THE YEARS

I n 1958, Auerbach's opened a parking terrace that one entered from State Street. And in the 1960s, "the multi-windowed structure was completely hidden by a new white concrete panel façade," wrote former newspaperman and television news director Jack Goodman.[55] "The new façade of mosaic stone sheets was literally hung over the steel and concrete frame of the old store. When opened, aluminum and glass doors led to a glittering gold and white structure."

In the 1970s, city beautification plans, narrower streets, parking snafus and city policy woes struck downtown businesses hard. That, coupled with shrinking pedestrian and automotive traffic, a dearth of Sunday shoppers and an alluring number of suburban malls, signaled an economic downturn. In 1977, the Auerbach family sold its store, and in 1979, it closed.

But the memories remained in the minds of those who held (and hold today) Auerbach's in high esteem. People "enjoyed walking the circle down Main Street from ZCMI, across Broadway to State Street and into Auerbach's, where they lunched and shopped," Goodman wrote. "The real goal was Auerbach's. There the ladies had favorite salespersons and tried on fashionable bargains. Those were the days, my friends. Who thought they would ever end?"

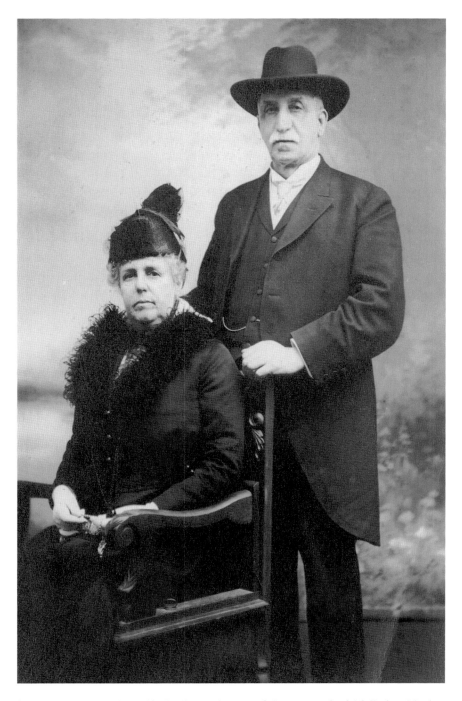

Samuel Auerbach and his wife, Eveline, at the turn of the century. *Special Collections, Marriott Library, University of Utah.*

LOOKING BACK: "HOW CAN YOU FORGET?"

—Salt Lake residents Becky McDermott and her sister Liz Davis[56]

Becky

I just have fond memories of when I was young in the early 1960s and my mom and I would go up to that little mezzanine in Auerbach's to eat. She would have a date nut and cream cheese sandwich, I would have a tuna fish sandwich and we both drank Cokes in these really cool-looking Coke glasses.

As I got a little older and we were living in the Indian Hills area of Salt Lake, my parents trusted me and my friend to take the bus downtown, see a movie at the Centre Theatre, right on the corner, and then go down in the Auerbach's basement, where they had a restaurant and goldfish in a pond with a statue similar to the one in the coffee shop at the Hotel Utah. Dad taught us how to leave a tip. So we left a little tip.

I remember my mom's metal Auerbach charge card that slipped into a green leather sleeve. It was silver, smaller than a regular business card and embossed with numbers. Mom would let us take it, and I remember using the charge card to buy my first pair of black patent leather Mary Jane shoes with a little bit of a heel. They were my favorite, and I felt very grown up.

My sister and I always went on Saturdays, and I wore fishnets and a dress—that's how you went downtown. Our dad was an attorney and worked a couple blocks [away] on Fourth South and State Street. So we'd call him and walk down there. And he'd take us back home. It was just a lovely life.

Liz

I remember that counter where you could sit. And it seems like they had three booths on one side and at least six booths on the other. I ate BLTs and drank chocolate malts. Becky always drank Cokes.

I must have been three or four years old when I first went to Auerbach's. It was an important store that sparkled with colors and cabinets that gleamed with glass and wood. That's where the lady with the hair combs worked. She was so beautiful.

And Christmastime, when we were older, maybe five or six, it was snowing. We were going out the Auerbach's door on Broadway and into a vestibule with two solid benches and a heater. I just remember being in there with wall-to-wall people. Mom and Dad put us on this little bench as they went to get a Christmas surprise, maybe for us. And we were supposed to stay there and not move. I remember how foggy the windows were and how we kept rubbing them to look out at the snow coming down. We wore those woolen coats with the little round collars, you know that kids wore in the '50s, and it was toasty nice and warm. Those were the good days.

As soon as I turned eighteen, I moved into an apartment on First Avenue and C Street, near downtown Salt Lake City. Since I had been a knitter most of my life and won ribbons at fairs, my mom thought I should work in the yarn department at Auerbach's. And I did. I learned how to use the pneumatic tube and how to talk to people. I was definitely the youngest

When night lights brightened downtown Salt Lake City. *Herbert Auerbach Collection, Marriott Library, University of Utah.*

person working there. There was an older woman, matronly, thin and a master knitter. People would come in with their knitting problems, sit at a table and wait to get instructions or help, most often from her. I would offer to help them out. I did know how to knit. But [they] would always say, "Well, I just want to check with Mrs. So-and-So to make sure." She was that good.

Becky
There was always a nice air about the salespeople, an air of sophistication, not snobbery. When Mom went there to buy a bra, they'd show her various ones in these almost see-through, pull-out drawers. They'd ask a few questions while going to the fitting room and always found the right style and fit for her.

Liz
I also remember when we bought Mom maternity clothes when she was pregnant with our sister. The salesperson there was really neat, picking out clothes that were just right for her. I think we bought her a real red coat with fur on the inside. Didn't we?

NOTES

Foreword

1. Michael Hallet telephone interview with author, December 1, 2017.

Chapter 1

2. See Destination America, www.pbs.org/destinationamerica.
3. Peter Black, "European Jewry," in *Homeland in the West: Utah Jews Remember* by Eileen Hallet Stone (Salt Lake City: University of Utah Press, 2001), 45–53.

Chapter 2

4. Judith Robinson, *Utah Pioneer Merchant: The Memoirs of Samuel H. Auerbach (1847–1920)* (Berkeley: University of California Press, 1998).

Chapter 5

5. Robinson, *Utah Pioneer Merchant*, 32.

Chapter 6

6. See online *Worcester Aegis and Transcript*, December 7, 1861; *New York Herald*, January 13, 1861, November 5, 1860: "Judge Betts entered an order condemning the ship *Erie* as a slaver and directing her to be sold by the Marshal."

7. University of Utah Marriott Library, Special Collections, Herbert S. Auerbach Papers, 1904–1925, Accn. 26567, Box 3, folder 1.

Chapter 11

8. For more on the Mormon flight to the West, see Hallet Stone, *Homeland in the West*, 2–3.

Chapter 12

9. Ted Wilson interview with author, Salt Lake City, January 17, 2017.
10. See mining's effect on Utah: Philip Notarianni, "Mining," *Utah Historical Encyclopedia*, heritage.utah.gov/history/uhg-mining.
11. Jill Abrams interview with author, August 9, 2017.
12. See online Utah Geological Survey, 22, Salt Lake City and County Building. According to the survey, the building was damaged during the 1934 earthquake. "To protect future earthquakes the building now sits upon a base-isolation system of rubber and steel 'shock absorbers' set between the foundation and the ground." Completed in 1989, "the $30 million retrofit was the world's first application of a seismic base isolation in the restoration of an historical structure."
13. For more on the Godbeites, see Eileen Hallet Stone, "Nineteenth-Century Mormon Woman Fought for Rights," *Hidden History of Utah* (Charleston, SC: The History Press, 2013), 120–22.

Chapter 13

14. For more on the Brooks family, see Hallet Stone, *Homeland in the West*, 55–71.
15. According to the National Register of Historic Places in Salt Lake County, the building was "intended to be six stories high," but it "apparently began to sink under the weight of its brick and stone superstructure, and only three stories were completed."

Chapter 14

16. Samuel Western, "Trade Among Tribes: Commerce on the Plains before Europeans Arrived," April 26, 2016, accessed December 9, 2017, www. wyohistory.org/encyclopedia/trade-among-tribes-commerce-plains-europeans-arrived.
17. Frank B. Linderman, *Plenty-coups, Chief of the Crows* (Lincoln: University of Nebraska Press, 2002).

18. David Wescott, *Primitive Technology II: Ancestral Skills* (Layton, UT: Gibbs Smith, 2001), 139–61.

19. Aaron Kind, manager, Chief Plenty Coups State Park, Pryor, MT, telephone interview with Randy Silverman, head of preservation and assistant dean for academic affairs, University of Utah Marriott Library, Salt Lake City, UT, December 7, 2017.

20. Andrew Garcia, *Tough Trip through Paradise, 1878–1879* (Boston: Houghton Mifflin, 1967), 7.

Chapter 17

21. Arthur C. King interview with author, Salt Lake City, January 27, 2017.

Chapter 18

22. Theodore Auerbach statement was found in *The Hebrew* 2, no. 3, San Francisco, November 17, 1865, WSJH.

Chapter 20

23. For more information on the turbulent trade wars, see Hallet Stone, *Homeland in the West*, 6–11.

24. Orson F. Whitney, *History of Utah* (Salt Lake City, UT: George Q. Cannon and Sons, 1893), 2:163–67.

Chapter 22

25. Brigham H. Madsen, *The Gentile Capital of Utah* (Salt Lake City: Utah Historical Society, 1980).

26. Bernice Gibbs Anderson, "The Gentile City of Corinne," *Utah Historical Quarterly* 9, nos. 3–4 (July, October 1941).

27. Eileen Hallet Stone, "Un-Godly Corinne Loved Being a Thorn in Early Utah's Side," *Hidden History of Utah*, 24–26.

28. Alene McCrimmon interview with author, April 10, 2016.

Chapter 23

29. Patty Greenwood telephone interview with author, July 25, 2017.

Chapter 24

30. Pam March interview with author, March 4, 2017.

Chapter 25

31. Dr. Richard D. Poll, "A State Is Born," *Utah Historical Quarterly* 21 (Winter issue 1964).
32. Sally Shaum, personal letter to author, Salt Lake City, December 5, 2017.

Chapter 26

33. Bureau of Labor Statistics, www.officialdata.org/1896-dollars-in-2018?amount =407500.

Chapter 27

34. Joan Smith telephone interview with author, Salt Lake City, March 8, 2017.

Chapter 28

35. Auerbach's Salt Lake Store Directory (no date) and online comments are edited from the Department Store Museum website, www.thedepartmentstoremuseum.org.
36. Daniel G.T. telephone interview with author, April 25, 2017.
37. Alyce Sheba telephone interview with author, Salt Lake City, November 10, 2017.
38. John Young interview with author, November 9, 2017.
39. Zoe Richardson interview with author, January 30, 2017

Chapter 29

40. For more on Harry Doctorman, see Hallet Stone, *Homeland in the West*, 251–57.
41. See Hallet Stone, "Before Refrigerators, Ice Was Harvested for Utah Iceboxes," *Hidden History of Utah*, 101–2.
42. Gail Bernstein telephone interview with author, December 6, 2016.

Chapter 30

43. Paula Van der Wiel conversation with author, Salt Lake City, August 13, 2017.
44. Eileen Hallet Stone, "In the 1890s, Utah's Women Found Freedom on Bicycles," *Hidden History of Utah*, 78.
45. Tanny Stayner telephone interview with author, December 2016.

Chapter 31

46. George's letters to Beatrice are in the Koopman Collection, Connecticut Historical Society archives.

47. Virginia Hale, *A Woman in Business: The Life of Beatrice Fox Auerbach* (n.p.: Xlibris, 2008), 56, 64.

48. "G. Fox & Co. Destroyed by Fire—Today in History: January 29," connecticuthistory.org/g-fox-co-destroyed-by-fire-today-in-history.

49. Rena Koopman interview with author, August 30, 2017.

50. Brooksie Koopman interview with author, September 16, 2017.

51. Liz Keller interviews with author, January 11 and December 4, 2017.

Chapter 34

52. Kenneth DeConde interview with author, July 16, 2016.

53. According to the March 30, 1945 *Salt Lake Telegram*, Herbert's sister, Madeline Auerbach Werner, had "been named president of Auerbach Co. by the board of directors to succeed her brother, the late Herbert S. Auerbach." Agnes L. Stewart was "elected to the board and appointed general manager of the company."

54. Beverly Frank interview with author, January 15, 2017.

Chapter 35

55. Jack Goodman, "Auerbach's Department Store," *As You Pass By: Architectural Musing on Salt Lake City* (Salt Lake City: University of Utah Press, 1995), 125; Mary Hopkins, "Those Were the Days," Apple Records, 1968.

56. Becky McDermott and Liz Davis interview with author, July 21, 2017.

FREDERICK H. AUERBACH
AUGUST 22. 1836.
SEPTEMBER 1. 1896.

ABOUT THE AUTHOR

Award-winning author and former *Salt Lake Tribune* columnist Eileen Hallet Stone's published works include *Historic Tales of Utah*, *Hidden History of Utah*, *A Homeland in the West: Utah Jews Remember* and *Missing Stories: An Oral History of Ethnic and Minority Groups in Utah*, coauthored by Leslie Kelen. Her commentary is featured in the 2015 documentary film *Carvalho's Journey*.

Author Eileen Hallet Stone visits Frederick H. Auerbach's highly esteemed cemetery plot in the B'nai Israel cemetery, Salt Lake City. *Photograph by Randy Silverman.*

Visit us at
www.historypress.com